D0646651

PICASSO'S PARIS
WALKING TOURS OF THE ARTIST'S
LIFE IN THE CITY

BY ELLEN WILLIAMS

THE LITTLE BOOKROOM
NEW YORK

Book Design: Angela Hederman
Composition and layout: Gina Webster

Cover: *Picasso on the Place Ravignan, 1904*. Archives Picasso, Musée Picasso, Paris © Photo RMN

Cover map: *Excursions dans Paris sans voitures, 1867*.

The Little Bookroom acknowledges with appreciation the contributions of Pietro Corsi, Margarette Devlin, Neil Gordon, Diane Seltzer, Michael Shea, and Jenie, Patrick, and Taylor Hederman.

Manufactured in Hong Kong by South China Printing Company (1988) Ltd.
ISBN 0-9641262-7-3

First Printing January, 1999

Published by The Little Bookroom
5 St. Luke's Place, New York NY 10014
(212) 691-3321 Fax (212) 691-2011

to Katharine Berkman

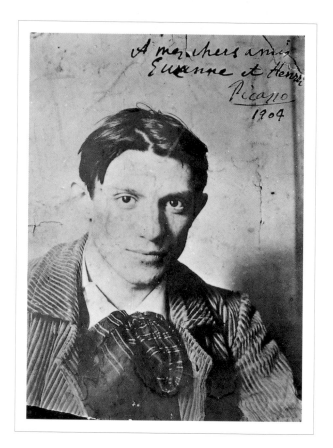

Picasso, *1904. Archives Picasso,
Musée Picasso, Paris*

CONTENTS

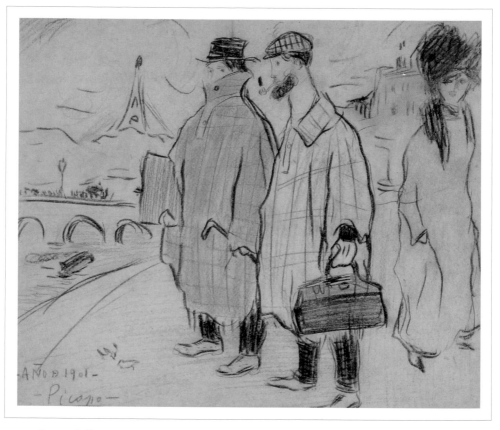

Picasso: Self-Portrait with Jaume Andreu Bonsons, Paris, *1901. Private Collection, London*

FOREWORD

BOOKS ABOUT PABLO PICASSO tend either to focus on the many styles he pioneered in his work (Blue Period, Rose Period, Cubism, Classicism, Surrealism) or to describe his colorful biography (the child prodigy who astonished until he was ninety, the starving artist who became the wealthiest painter who ever lived, and, of course, all those women). This book is about the Spaniard who, along with scores of other aspiring creative people, was drawn to Paris at the turn of the century and how in that great city he came to be the greatest artist of our time.

Time and place came together for Picasso as he arrived in Paris in 1900: a young man at the start of his career in the cultural capital of the world at the dawn of a new age. "Paris was where the twentieth century was," Gertrude Stein, Picasso's friend and champion, later observed. "Paris was the place to be." Had Picasso stayed in Spain, would he have achieved all he eventually did? Or did he go to the one place where his talent could become his genius? Coming down decisively on the crucial role of the city in the artist's life, the critic John Russell has declared, "Without Paris . . . Picasso would not be Picasso."

SIMILARLY, WITHOUT PICASSO, PARIS would not be the Paris it is today. For more than half a century, the artist's contemporaries responded to the force of his presence in the city, first as the most

innovative *enfant terrible* and then as the grand old man of Modernism. Neighborhoods assumed and then lost their status as the hub of the art world according to his movements. And, in large part as a result of Picasso's triumphs, mainstream Parisian society, after decades of assault from upstart radical painters, at long last embraced as high culture the daring and new over the tired and stale.

Picasso's stays in several of the city's districts in many ways constituted several distinct lives, so different were the times, so diverse his enormous output, so varied his homes, his companions, and the streets through which he traveled. The four walks in this book cover his four Paris neighborhoods – two on the Right Bank, two on the Left:

♦ BOHEMIAN MONTMARTRE, where the young tourist first settled in the early years of the century

♦ MONTPARNASSE, where the leader of the avant-garde held court in the cafés before and during World War I

♦ The elegant ÉTOILE QUARTER, where the world-famous millionaire lived *le high life* in the Twenties and Thirties

♦ The medieval streets of SAINT-GERMAIN-DES-PRÉS, where the venerated aging artist became a symbol of first the occupied and then the liberated French capital

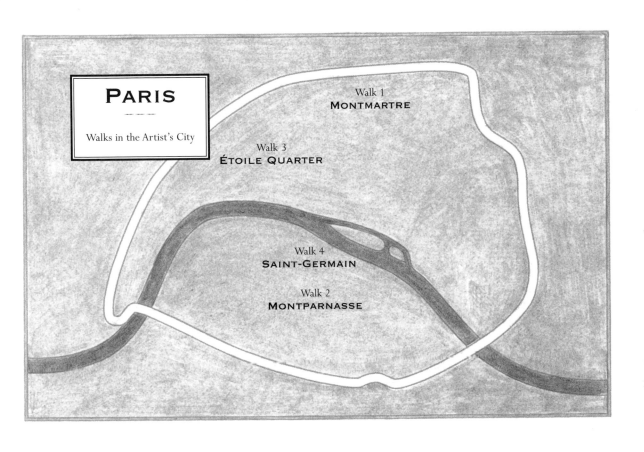

PARIS

Walks in the Artist's City

Walk 1
MONTMARTRE

Walk 3
ÉTOILE QUARTER

Walk 4
SAINT-GERMAIN

Walk 2
MONTPARNASSE

T HESE WALKS TAKE THE traveler not only through Paris the geographic location, but also through a city that was the meeting place of the most creative minds of the early and mid century. Picasso arrived in this culturally chauvinistic country not knowing a word of the language and decades later still spoke it with a heavy accent, speaking "French in Spanish," one of his friends remarked. Even Picasso's mistress Fernande Olivier found his success there baffling, asserting, "I never knew a foreigner less suited for life in Paris." And yet he would become the foremost of those artists collectively known as the School of Paris. Though he stood barely five foot three, he was the giant who cast an enormous shadow in a city full of prodigious talent and dedication. Naturally Picasso mixed with the great painters, sculptors, and photographers of the period – Matisse, van Dongen, Gris, Derain, Braque, Modigliani, Léger, Chagall, Man Ray, Brassaï, Giacometti, de Chirico, Brancusi, Balthus, Dali, and many others. But he also crossed paths with a remarkably varied collection of noted and notorious residents and visitors of various levels of Parisian society: Max Jacob, Guillaume Apollinaire, Gertrude Stein, Ernest Hemingway, Jean Cocteau, Sergei Diaghilev, Igor Stravinsky, Erik Satie, Isadora Duncan, James Joyce, Josephine Baker, Coco Chanel, Maurice Chevalier, Jean-Paul Sartre, and Simone de Beauvoir among them.

THIS PARIS – HOW AND when and where Picasso lived and worked in it, drew inspiration from it, and left his mark on it – is the focus of these tours. The main sites of each walk (indicated by blue

ovals) are, with a few exceptions, arranged in chronological order. At each stop, scrapbook items provide related anecdotes about the area, the figures in the artist's circle, or contemporary Paris history. Important addresses (red dots) and conveniently located cafés and bistros that Picasso frequented or that existed in those neighborhoods when he lived there (brown dots) can all be located on the appropriate map. Additional sites mentioned in the text are indicated by black dots.

Most of Picasso's Paris still exists today. Yes, Montmartre is crawling with tourists – something the artist and his friends bemoaned as early as 1910 – and Montparnasse is no longer the mecca of the international avant-garde. There are more movie theaters than mansions on the Champs-Élysées and in the surrounding Étoile Quarter; more elegant boutiques than existentialists in Saint-Germain. *La vie de bohème* has become a luxury few starving artists can afford anywhere in Paris. But beyond the changes expected in 50 to 100 years of urban development, much more of the city Picasso knew remains than has disappeared.

PABLO RUIZ Y PICASSO was born in Malaga in southern Spain on October 25, 1881, his father a modestly talented art instructor. The family eventually settled in Barcelona, where Pablo, an exceptionally gifted adolescent, became part of the Catalan avant-garde and received the honor of having his work accepted for the Spanish pavilion at the Paris World's Fair of 1900. A two-month stay to see the exposition was his first time abroad, a first taste of the fabled French sophistication and *joie de*

vivre he and his friends had dreamed of. Over the next few years he made two repeat visits, each time returning home, each time finding it increasingly difficult to conform to the creative strictures demanded by both his artistically conservative father and his far more repressive native land. He became so emotionally attached to his adopted French city that on one trip home he became irate when his mother removed the dust of Paris from his boots. Picasso knew that only there could he find the intellectual and spiritual stimulation, the confidence and optimism, the appreciation and reward he needed. "He came there," the poet Maurice Raynal observed, "to find a cure for life." And so in the spring of 1904, the twenty-two-year-old packed his belongings in a wooden suitcase and once again crossed the Pyrenees in a third-class rail coach. Despite the fact that the artist never gave up his Spanish citizenship, he only went back to visit about a half-dozen times, never returning after Franco came to power.

PICASSO ARRIVED IN THE gas-lit *Belle Epoque* Paris of Sarah Bernhardt, where tightly corseted women stepped from horse-drawn carriages. More than fifty years later, he moved his main residence to the South of France, after two world wars, a global depression, and untold scientific and technological developments, at a time when the creative world was shifting its attention away from Paris and toward New York. By the mid-Sixties when the artist left the capital for the last time, two million cars swarmed through a City of Light of glowing neon marquees brightly proclaiming the latest

film of a scantily clad Brigitte Bardot. Today, at the turn of another century, Picasso's decades-long life in Paris has contributed to the way the city is perceived by both its inhabitants and visitors. Following in the footsteps of this one extraordinary inhabitant can reveal entirely new aspects of the city even to those familiar with it.

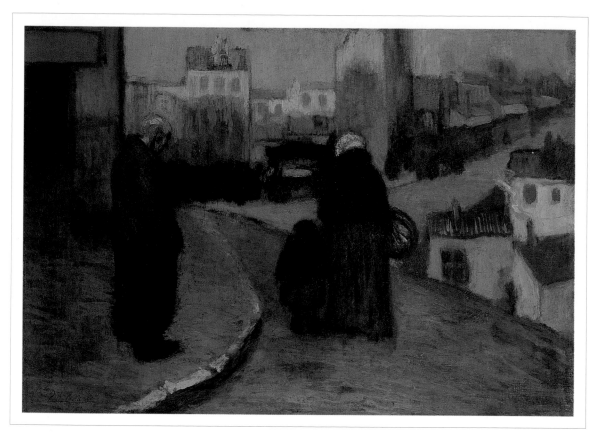

Picasso: Street Scene, Paris, 1900. *San Francisco Museum of Modern Art*

WALK 1
MONTMARTRE

MONTMARTRE, THE NAME OF the hill, *la butte*, and the village perched along its steep flanks, had been a part of the city for only forty years by the turn of the century. The highest point in Paris, its difficult access had spared it from Haussmann's massive urban renewal that had gutted many older parts of town to create the broad boulevards lined with nearly identical six-story buildings. Located on the northern outskirts and still largely rural and working-class, Montmartre was a refuge for struggling artists attracted by its inexpensive garrets, the quality of the hilltop light, the exuberant night life, and by the romantic legend of the Realists, Impressionists, and Post-Impressionists who had once toiled there in defiance of the powerful artistic establishment of the city below.

It was in this district in October 1900, shortly before Picasso's nineteenth birthday, that he and the poet Carles Casagemas, settled when they arrived to celebrate the inclusion of Picasso's painting in the Spanish pavilion at the Exposition Universelle. They visited the fair and saw the Old Masters in the Louvre and more recent art at the Musée du Luxembourg, then the museum of contemporary art. But they spent most of their time in Montmartre, discovering freedoms denied them at home. They could paint nude female models for the first time, sleep all day or stay out all night in the cafés and cabarets they knew from the paintings of Manet, Degas, and Toulouse-Lautrec.

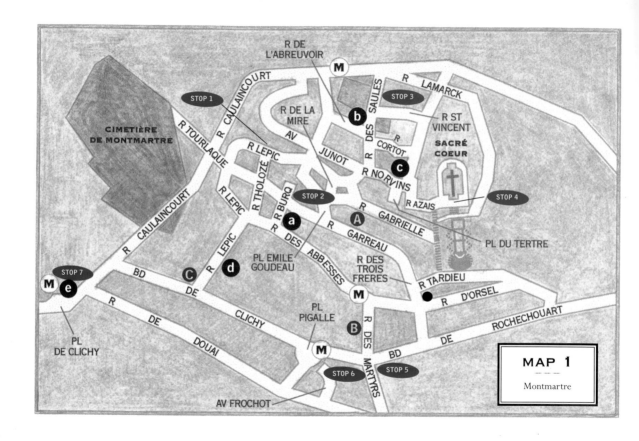

MAP 1

Montmartre

LEGEND

STOP 1 Le Moulin de la Galette – 79, rue Lepic

STOP 2 Le Bateau-Lavoir, residence of Picasso (1904-09) – 13, place Émile-Goudeau

STOP 3 Le Lapin Agile – 22, rue des Saules

STOP 4 Le Sacré-Coeur

STOP 5 Site of the Cirque Médrano – 63, boulevard de Rochechouart

STOP 6 Residence of Picasso (1909-12) – 11, boulevard de Clichy

STOP 7 Studio of Picasso (1901-02) – 130*ter,* boulevard de Clichy

A Studio of Picasso (1900) – 49, rue Gabrielle

B Site of Le Divan Japonais – 75, rue des Martyrs

C Le Moulin Rouge – 90, boulevard de Clichy

a Le Moulin à Vins – 6, rue Burq

b La Maison Rose – 2, rue de l'Abreuvoir

c La Mère Catherine – place du Tertre

d Lux-Bar – 12, rue Lepic

e Le Wepler – 14, place de Clichy

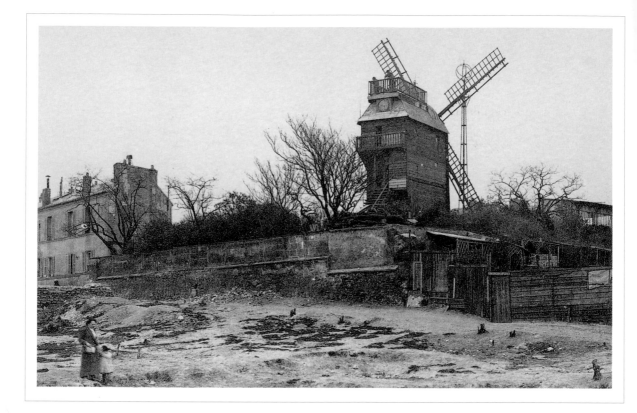

 STOP 1 *Le Moulin de la Galette, 79 rue Lepic*

Metro: Abbesses or Lamarck-Caulaincourt

O NE OF THE BEST known Montmartre gathering places, the Moulin de la Galette was an open-air dance hall situated beneath the last two remaining windmills (*moulins à vent*) that had once dotted this breezy hilltop. It had been painted by van Gogh, Toulouse-Lautrec, and Renoir – Picasso saw this enormous canvas at the Musée Luxembourg; today it is one of the highlights of the Musée d'Orsay. But just as these older artists inspired Picasso, they also challenged him to find his own style. And so his first major painting in Paris was a reinterpretation of their views of this hallowed neighborhood spot, located at the summit of the Butte, just two blocks from the studio he and Casagemas sublet at 49, rue Gabrielle (A).

Renoir had depicted the Moulin in 1876, in its heyday, on a sparkling summer afternoon when artists and working men and women came to waltz in their Sunday best. A quarter century later, this wholesome scene had become completely transformed. Now the province of pimps and prostitutes as well as the Catalan community into which the young Spaniards had settled, the Moulin was a seedy

Picasso: Moulin de la Galette, *1900. Solomon R. Guggenheim Museum, New York*

dive. Picasso, painting the indoor dance parlor a few weeks after arriving in the city, turns up the gaslight to exaggerate the harshness of the colors and shadows, the garish clothing and makeup of the

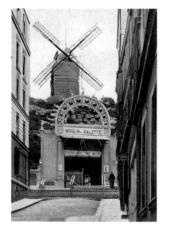

harlots lying in wait for customers.

Picasso had promised his parents he would be home for Christmas, so after just two months in Paris that would change both their lives forever, he and Casagemas reluctantly returned to Spain.

The Moulin de la Galette survived until 1960.

Picasso would soon visit Paris twice more before permanently settling there in 1904. However, to avoid walking down the hill and back up again, these sites will be visited later (pages 59 and 136). Walk east along the rue Lepic two blocks, turning right down the rue de la Mire to the rue Ravignan, continuing to the place Émile-Goudeau.

Ⓐ 49, rue Gabrielle

For their two-month stay in the autumn of 1900, Picasso and Casagemas rented the large top-floor studio here from the Spanish painter Isidro Nonell. A third friend soon joined them as did a trio of models, Picasso pairing off with Odette; Casagemas falling desperately — tragically, it would turn out — in love with Germaine. The teenagers reveled in the neighborhood and in their simple Parisian garret, writing a friend back in Barcelona about whom they'd seen and where they'd gone. They even included an inventory of the simple furnishings here: ". . . two green chairs and a green armchair, two chairs that aren't green . . . a corner cupboard that isn't in a corner . . . two pillows and a lot of pillow cases, four more pillows without cases."

Le Maquis

Literally a wild scrub land, this area on the northwest slope of the hill behind the Moulin de la Galette was a dangerous shantytown, a warren of tarpaper shacks where the most destitute artists could find a place to work among junk men, thieves, and murderers. In 1910 the area was cleared for construction of the avenue Junot.

Three artists who influenced Picasso's early work had recently lived in the vicinity of the Moulin de la Galette. On the rue Caulaincourt, Toulouse-Lautrec had resided at no. 27, Steinlen at no. 21. Van Gogh and his brother shared lodgings at 54, rue Lepic.

The Exposition Universelle

Picasso was among fifty million visitors to the Paris World's Fair of 1900, the largest international exposition to date and a spectacular send-off for the new century of progress. The centerpiece was the Palace of Electricity – prompting the now-familiar nickname *ville lumière*, "City of Light" – with its dramatic nightly illuminations of the various halls and pavilions that had been erected to surround the eleven-year-old Eiffel Tower. Among these was the Spanish Pavilion, modeled on a Castilian castle, where the young Pablo Ruiz – before he took up the more distinctive last name of his mother – was among the fea-

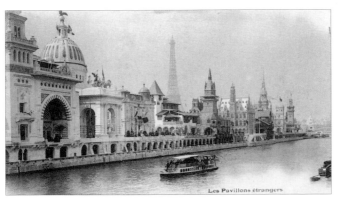

Les Pavillons étrangers

tured artists, showing a canvas that was never photographed before he painted over it three years later with the haunting Blue Period composition *La Vie*.

Several structures built for the exposition are now Parisian landmarks: both the Petit and Grand Palais (where an impoverished Henri Matisse was paid by the yard for decorating the walls with garlands), the Pont Alexandre III (with its gilded statues and gas-fitted candelabra, it remains the most ornate bridge in the city), and the Gare d'Orsay (the train station where Picasso first arrived in the city and today home to the museum of nineteenth-century art).

Picasso and Fernande in Montmartre,
c. 1906. Archives Picasso, Musée Picasso. Paris

The Bateau-Lavoir, 13, place Émile-Goudeau
Picasso's residence, 1904-1909

T HIS SIMPLE CONCRETE STRUCTURE is a replica of the wooden building that burned in 1970, a hovel that has been called the Medici Villa of Modern Art and the Acropolis of Cubism but is best known simply as the Bateau-Lavoir ("the laundry barge"), after its resemblance to the swaying washing shacks moored along the Seine. In this unlikely spot Picasso found his proverbial fame and fortune and changed the history of art forever.

The building – a former piano factory that had been converted into studios in the 1880s – was actually much larger than it appeared; another four stories clung precariously to the side of the hill as it descends to the rue Garreau. When one of its thirty studios became available in April of 1904, Picasso returned from Spain, paying just fifteen francs a month for rent.

The pristine facade of today in no way reflects the peeling walls and rotting shutters of the lopsided, ramshackle tenement that faced the street nearly a century ago when the address was 13, rue Ravignan. Inside Picasso and the other tenants – laborers, students, writers, and artists, including

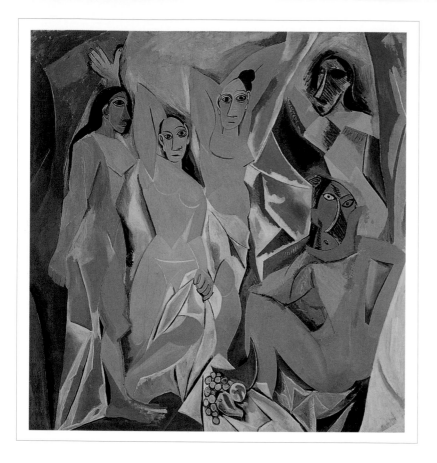

Picasso: Les Demoiselles
d'Avignon, *1907.*
The Museum of Modern Art,
New York

Juan Gris, Kees van Dongen, and Amedeo Modigliani — shared one leaky faucet and one toilet situated in the dark, narrow corridor that led to the individual studios.

IF THE BUILDING WAS A dilapidated slum, no one room was worse than Picasso's. This and all his later studios were universally described as filthy — scores of canvases piled up beside the easel, the floor littered with half-squeezed tubes of paint, brushes, rags, jars of turpentine, scraps of paper, cigarette butts — a chaotic mess the artist evidently needed in order to create. A rusted iron stove provided the only heat; a chipped earthenware bowl served as the sink. As there was no gas or electricity, Picasso often held a candle in order to work at night. In this squalor he was eventually joined by a menagerie that included three dogs — Gat, Feo, and Fricka — and a tame white mouse that lived in a drawer, and by an auburn-haired beauty named Fernande Olivier, the first of the seven long-term mistresses and wives who are so familiar in his work. Years later she described this "strange and sordid house" as a Turkish bath in the summer (when the artist would paint in the nude) and glacial in the winter (tea left overnight in the bottom of a cup would be frozen the next day), a place where "the most diverse noises resounded from morning to night . . . the racket of slop pails being emptied and dropped to the floor, the noise of pitchers being set down on the stone of the fountain, doors slammed, and the most questionable groans which passed right through the closed doors of these studios. Laughs, cries, we heard everything; all resounded without reserve."

THE ATELIER, WHICH WAS said to smell of "dog and paint," quickly became the rendezvous for the growing collection of friends and admirers of the artist, who, with the city of Paris literally at his feet, rarely left Montmartre. The poets Max Jacob, Guillaume Apollinaire, and André Salmon crossed through the unpaved, tree-dotted *place* almost nightly before heading on with Picasso to one of their local haunts. Le Zut at 28, rue Ravignan was a dirt-floor shack, rat-infested and often dangerous. At Fauvet, just down the rue Ravignan at the rue des Abbesses, Salmon proudly recalled, "poets and painters fraternized with vagrants." Here they drank *mominette*, a type of absinthe made from potato alcohol, or the cheapest possible wine, which they called "red ink," and marveled at the main attraction, a new coin-operated electric organ.

The American connoisseurs Leo Stein and his sister Gertrude, who sat for her portrait at the Bateau-Lavoir (see stop 10), also became enthusiastic supporters, buying works – 800 francs worth on their first visit alone – bringing other collectors, and even agreeing to pay the rent on an additional studio in the building in 1907 when Picasso felt he needed more room to begin a monumental new canvas.

For the general composition of this painting Picasso turned to Cézanne, who had died only the year before. A group similar to the older master's bathers, however, eventually gave way to five enormous prostitutes. Their bodies were violently fractured into a dozen different planes; their faces inspired by both ancient Iberian art (Picasso had just bought two such statuettes that had been stolen

from the Louvre which he kept hidden in the bottom of a cupboard) and by African masks (he had recently discovered tribal art at the Musée Ethnographie – today the Musée de l'Homme – at the Trocadéro). The ground breaking *Desmoiselles d'Avignon*, painted here, was at first reviled – even Matisse thought it was a hoax – but came to be considered the first masterpiece of twentieth-century art. The painter rolled up the canvas and put it away until 1916, when he finally exhibited it.

AFTER FIVE YEARS AT the Bateau-Lavoir, which despite its harsh realities, Picasso would always remember as the happiest time of his life, he and Fernande moved out. They took a typical bourgeois

apartment at the foot of Montmartre, the rising star's first tentative steps away from *la vie de bohème* of his early days in Paris.

The 1970 fire destroyed the original building just months after it had been declared an historic monument that was to have been restored as a museum. Today, the city of Paris rents the studios of the rebuilt Bateau-Lavoir to artists far more prosperous than its original tenants.

Head up the rue Ravignan through the place Jean-Baptiste Clément to the rue Norvins. Continue along the rue des Saules two blocks to the rue Saint-Vincent.

ⓐ Le Moulin à Vins

A rustic wine bar near the Bateau-Lavoir.

6, rue Burq
01.42.52.81.27
Tu–Fri 11am–4pm,
6pm–2am; Sat. 6pm-2am
Métro: Abbesses

Henri Rousseau

When Picasso unearthed a large portrait of a woman at a junk shop opposite the Cirque Médrano (stop 5) by the Douanier Rousseau, the dealer assured him that he could paint over the canvas, priced at a mere five francs. But Picasso was overwhelmed by the simple power of Rousseau's work and set about organizing a banquet to honor the unappreciated retired toll collector then living across the city in Montparnasse. The party at the Bateau-Lavoir in November 1908, was something of a fiasco – the catered food Fernande had ordered was not delivered until the next day, some of the guests became drunk and disorderly – that later became a part of the legend of the colorful days of pre-war Montmartre. Picasso kept the Rousseau until his death and today it hangs with the rest of the art he collected and his own work at the Musée Picasso.

◇◇◇

Picasso's door at the Bateau-Lavoir was always open to friends despite the few amenities the hosts could offer. Newspaper was the only table linen; Fernande once suggested that four dinner guests each take a corner of the household's single cloth napkin.

Marie Laurencin

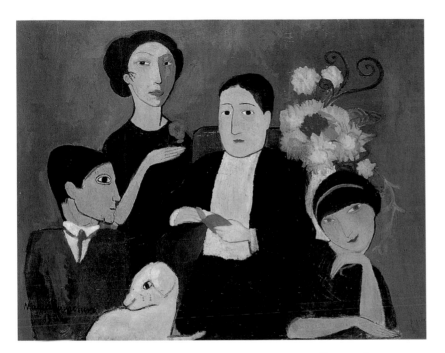

Marie Laurencin: Group of Artists, 1908. The Baltimore Museum of Art

Picasso met Laurencin, a native of Paris, through Georges Braque and then played matchmaker, introducing her to Guillaume Apollinaire, who, indeed, became her lover for several years. This canvas, the first Laurencin ever sold (to Gertrude Stein), shows her and the poet flanked by Picasso, holding his beloved dog Fricka, and Fernande Olivier. The two couples were often together although the women did not care much for one another.

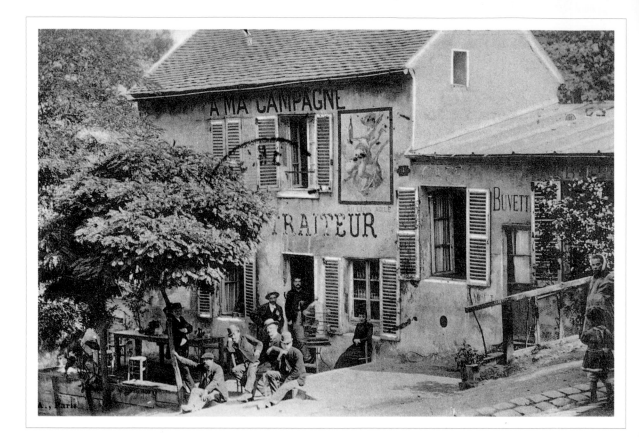

STOP 3 *Le Lapin Agile*
22, rue des Saules

T HIS CABARET, OPPOSITE THE last remaining vineyard in Paris, is one of the enduring landmarks of the free and easy Montmartre of legend. At the time Picasso and his friends began gathering here the building already had a long history, having been a coach inn in the eighteenth century. After 1880, it took its name from a pun provoked by the clever sign painter André Gill: his rabbit (*le lapin à Gill*) was an agile rabbit (*le lapin agile*), deftly hopping out of the cook's copper pot. Young artists and writers joined local residents – often petty criminals and anarchists – for folk songs, poetry readings, a two-franc Burgundian dinner, cheap wine, or the house cocktail, pernod mixed with grenadine and kirsch.

Picasso's circumstances had improved somewhat by the winter of 1904–05 when he began the canvas for and about the Lapin Agile. He had recently painted the last of his nearly monochromatic blue pictures of human suffering (see stop 7), here brightening his palette but retaining the melancholy mood. Basing his composition on Toulouse-Lautrec's well-known poster for the nearby Divan

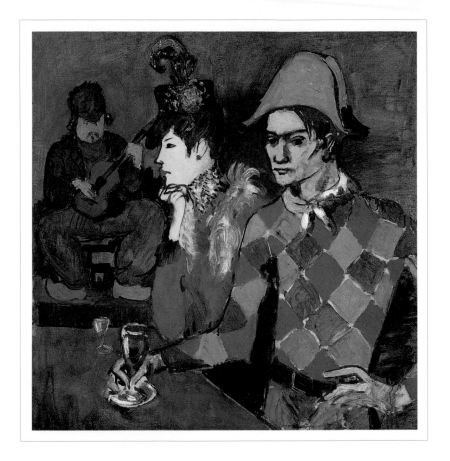

Picasso: At the Lapin Agile,
*1905. The Metropolitan Museum
of Art, New York*

Japonais (see page 49), Picasso took his subject of absinthe drinking from works by Manet and Degas. He places himself dressed as a harlequin standing beside Germaine Gargallo, the woman his friend

Casagemas had killed himself over (see stop 7), at the cabaret's bar; in the background Frédé, the manager, entertains customers with his guitar.

By the First World War, Frédé's entrepreneurship and the growing fame of Picasso and his entourage had destroyed the atmosphere of the Lapin Agile for its regulars as more and more tourists and bourgeois Parisians came there in search of a bohemian experience. In 1912 Frédé sold the canvas as Picassos were beginning to fetch large sums. Seventy-five years later the work the artist had probably traded for meals and drinks was auctioned for over forty million dollars.

Walk back down the rue des Saules to the rue Norvins, turning left to reach the place du Tertre. On the other side of the square turn right onto the rue Saint-Eleuthère a few yards to the rue Azaïs, continuing to the terrace below the Sacré-Coeur.

Maurice Utrillo

This eccentric alcoholic, the illegitimate son of the painter Suzanne Valadon, was also a regular at the Lapin Agile, often in the company of another dissolute artist, the Italian Amedeo Modigliani. Utrillo painted the front of the cabaret, the place du Tertre, the Sacré-Coeur, and most of the picturesque winding streets of his native Montmartre, often working from picture postcards, often mixing plaster of Paris into his white paint to achieve the distinctive rough texture of his buildings. He and his mother lived for a time around the corner on the rue Cortot, first at no.2 and then again at no.12 (today the Musée Montmartre), where Renoir – rumored by some to have been his father – had once kept a studio. Erik Satie, a future collaborator of Picasso's, lived at 6, rue Cortot, while he and Valadon had a stormy affair. Unlike the more radical artists who all abandoned the area in Picasso's wake, Utrillo remained in Montmartre. Appropriately, he is buried in the small Cimetière Saint-Vincent directly across from the Lapin Agile.

Maurice Utrillo:
Rue Norvins,
Paris, *c. 1910.*
Brooklyn Museum
of Art

ⓑ La Maison Rose

This small restaurant stands on a street named for a water trough for the horses that had climbed to this steep location. Germaine Gargallo, the woman pictured in *At the Lapin Agile*, lived at "The Pink House" for

more than forty years. 2, rue de l'Abreuvoir. 01.42.57.66.75 Daily noon-2pm, 7:30pm-1am Métro: Lamarck-Caulaincourt

In good weather Picasso would often sit out on the small terrace of the Lapin Agile beneath the old acacia tree with his dogs, accompanied by Frédé's donkey, monkey, and tame crow, pictured in this delicate pastel and watercolor with the owner's daughter Margot.

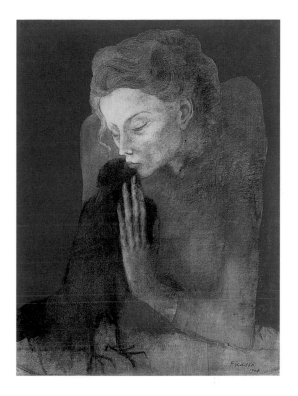

Picasso: Woman with a Crow, *1904. Toledo Museum of Art, Ohio*

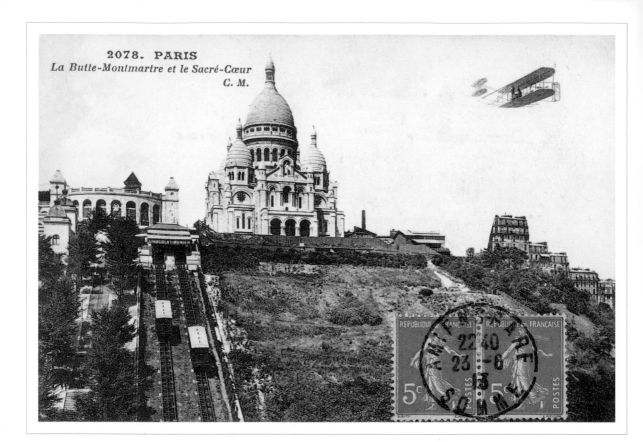

2078. PARIS
La Butte-Montmartre et le Sacré-Cœur
C. M.

Le Sacré-Coeur

CROWNING THE SUMMIT OF the Butte, the basilica of the Sacred Heart is the most identifiable symbol of Montmartre, visible throughout the city. Though begun in 1876, it was still under construction when Picasso arrived in the neighborhood at the turn of the century and would not be consecrated until after the First World War. The enormous bright white edifice, with its huge central cupola surrounded by four smaller domes and a bell tower, is primarily the work of Paul Abadie in a style usually described as Neo-Byzantine. In 1909 Picasso was inspired to fragment its towers and turrets in a silvery white composition, one of his rare views of a Parisian landmark, when he painted it from the window of his new apartment on the boulevard de Clichy (stop 6).

The style of course was Cubism, with its fractured planes and multiple viewpoints, which Picasso had begun to explore in the *Desmoiselles d'Avignon*. The early innovations would be fully developed in partnership with Georges Braque, the only such relationship in Picasso's long career. Braque, who had been working in the brightly colored Fauve style, was brought to the Bateau-Lavoir in 1907 to meet Picasso and to see his notorious new painting that everyone was talking about. Though ini-

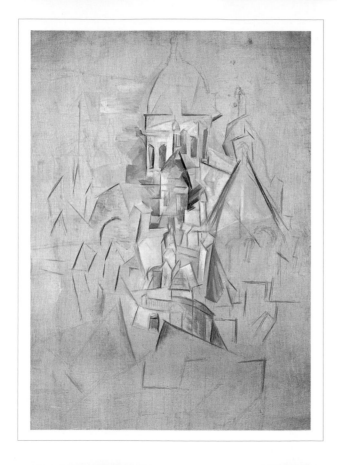

Picasso: Sacré Coeur, *1909.*
Musée Picasso, Paris

tially stunned, Braque quickly came to understand the revolution the Spaniard had ignited with the work. The two embarked on an intense, six-year collaboration, shuttling back and forth daily

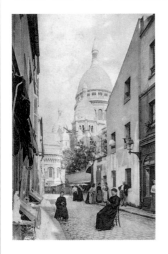

between their Montmartre studios – Braque's was at 48, rue d'Orsel and then at the Hôtel Roma on the rue Caulaincourt where he advised the owner to post a sign boasting "Cubists on Every Floor." Together they invented the new pictorial language that altered the course of painting as it had existed since the Renaissance. The Frenchman likened their relationship to a team of mountain climbers ascending a great height roped together. Picasso saw them as like the Wright brothers, then seeking to conquer the air, and took to calling his partner "Wilbourg" for Wilbur. Sometimes he would refer to Braque as his "wife," later, after they went their separate ways, as his "ex-wife."

Walk down the steps in front of the basilica to the rue Tardieu and head to the right. At the rue des Trois Frères turn left to the rue d'Orsel. Turn right and continue to the rue des Martyrs. Turn left, walking down to cross the boulevard de Rochechouart.

◇◇◇

C La Mère Catherine

Frequented by the Bateau-Lavoir circle, this restaurant was founded nearly two centuries ago. It is the oldest establishment on the crowded square — tertre means knoll or hillock — then as now the center of life in Montmartre.

Place du Tertre
01.46.06.32.69
Daily noon-3pm,
7pm-12:30am
Métro: Abbesses

The campanile of the Sacré-Coeur was added in 1904 to house the eighteen-ton "Savoyard," still one of the heaviest bells in the world. Henry Miller once described the basilica, which seems to float above all Paris, as "a dream embedded in stone."

Georges Braque

Born outside Paris in Argenteuil, in 1882, Braque moved to Montmartre in 1900, the same year Picasso first visited there. More than six feet tall – Gertrude Stein often called upon him to hang her many pictures at the rue de Fleurus (stop 10) – he and the very short Picasso made a striking pair.

A great athlete who loved boxing and car racing, the handsome Braque was also a wonderful dancer and musician. Although he seldom painted any landscapes, Braque was also inspired by the view of the basilica from his atelier at the Hôtel Roma.

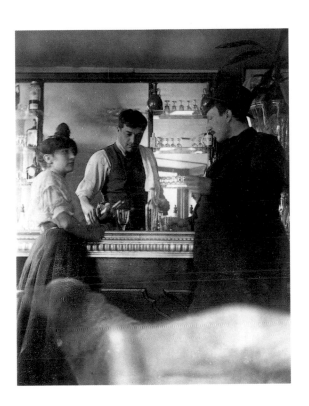

Picasso: Portrait of Fernande Olivier and Georges Braque, *1908-10. Archives Picasso, Musée Picasso, Paris*

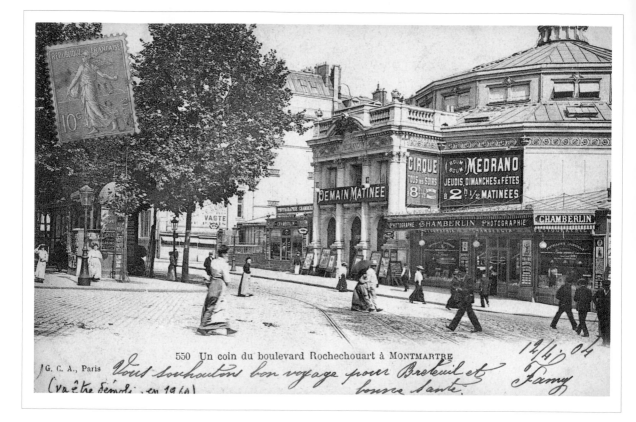

550 Un coin du boulevard Rochechouart à MONTMARTRE

G. C. A., Paris

Vous souhaitons bon voyage pour Breteuil et bonne santé.

(va être démoli en 1910)

12/4 04

Famy

Site of the Cirque Médrano
63, boulevard de Rochechouart

A T THIS CORNER AT the foot of *la butte* stood one of the most distinctive buildings in the city, the sixteen-sided stone Cirque Médrano. It was one of several permanent circuses in *fin-de-siè-cle* Paris, but the only one open all year round and the least expensive – tickets for the 2500 seats ranged from fifty centimes to three francs. During his years in Montmartre the Médrano, which was named for its owner, the clown Geronimo "Boum Boum" Médrano, was one of Picasso's favorite places and he and his friends often came three or four times a week as funds allowed, often spending the evening chatting with the performers at the bar. The bohemian artists were comfortable with circus people, fellow outcasts from mainstream society. Picasso felt a special appreciation for the feats of physical prowess by the bareback riders, strong men, acrobats, and especially the clowns – harlequins, pierrots, columbines, and saltimbanques – whose seemingly effortless displays of talent were not unlike his own. But it was not the performances that made their way into his work. Unlike Renoir, Degas, Toulouse-Lautrec, and Seurat, who had each painted the spectacle here when it was

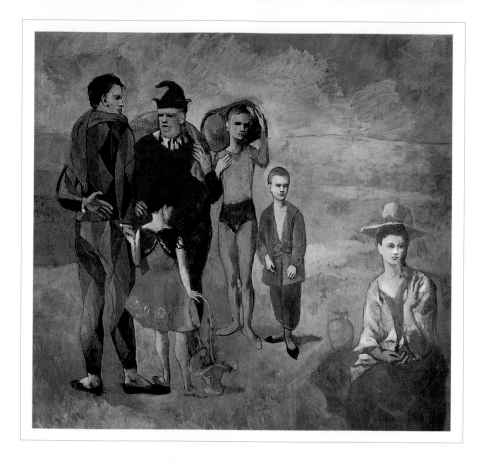

Picasso: Family of
Saltimbanques, *1905.*
The National Gallery
of Art, Washington, D.C.

known as the Cirque Fernando, Picasso preferred to show the grace and vulnerability of the Médrano's cast of characters offstage, their melancholy inner lives at odds with the exuberant outward appearance of their costumes.

Circus figures begin to appear in Picasso's work during the first visits to Paris and recur throughout his long career, but make their greatest impact during the so-called Rose Period of 1904-06. In fact, some have speculated that the warm pink tones that came to dominate Picasso's work at this time were suggested to him by the peach color of the Médrano's awning. The largest circus canvas is the *Family of Saltimbanques*, influenced by one of Manet's early works of a group of itinerants. Among the figures Picasso includes a taller version of himself as the harlequin at the left standing beside a little girl based on his concierge's daughter, who played outside his Bateau-Lavoir window. The Médrano was demolished in 1970.

Cross the rue des Martyrs, where the boulevard changes its name to Clichy, and continue half a block west stopping in front of no. 11.

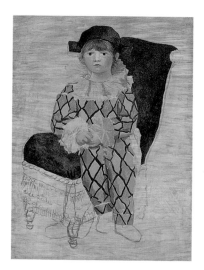

Picasso: Paulo as Harlequin, *1924.*
Musée Picasso, Paris

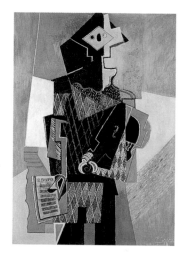

Picasso: Harlequin with Violin
("Si tu Veux"), *1918.*
The Cleveland Museum of Art

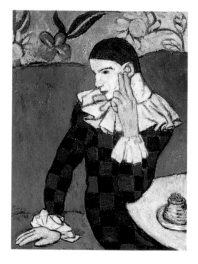

Picasso: Harlequin, *1901.*
The Metropolitan Museum of Art,
New York

In their most impoverished days, Picasso and his friends would spread out their canvases on the sidewalk in front of the circus, offering them for as little as a hundred sous (twenty centimes).

◇◇◇

So itinerant performers would not have to adapt their acts to each new venue, circuses throughout France all consisted of a single eighteen-meter ring, with the entrance and exit directly opposite one another.

◇◇◇

Years after he left Montmartre Picasso fondly reminisced: "We would buy cheese and bread and eat seated on a bench in the place du Tertre or place Ravignan." Such a picnic can be assembled today at two turn-of-the-century shops on the rue des Martyrs: Fromagerie Molard, a cheese shop at no.48; and for sausage or cold cuts, Terrier Charcuterie, at no.58. L. Chevalier, the boulangerie at 9, rue Norvins, at the top of the triangular place Jean-Baptiste Clément, in business since around 1800, can supply a crusty baguette.

B Le Divan Japonais

75, rue des Martyrs

Toulouse-Lautrec's famous poster for this cramped little cabaret inspired Picasso's *At the Lapin Agile* (stop 3).

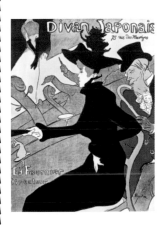

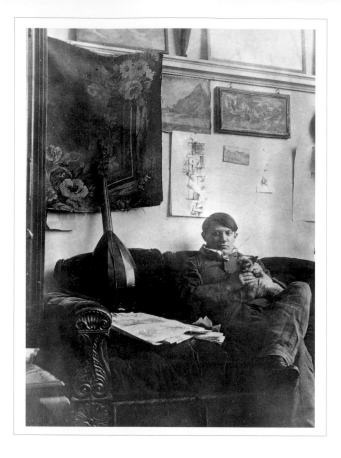

Picasso: Self-Portrait in the studio at
11, boulevard de Clichy, *1910.*
Archives Picasso, Musée Picasso, Paris

STOP 6 *11, boulevard de Clichy*
Picasso's residence, 1909-1912

J UST AS THE BROAD thoroughfares through central Paris are known as the *grands boulevards*, the continuous avenues that once marked the northern city limits – named variously boulevard de Rouchechouart, de Clichy, de Batignolles as they arc from east to west – are the *petits boulevards*. Before the communities beyond were annexed to the city in 1860, tolls – such as the one where the *douanier* Rousseau had worked – were set up along this stretch to tax goods entering Paris. Dozens of cafés, cabarets, taverns, and brasseries established themselves here, boasting duty-free wines that were cheaper than elsewhere in town.

It was to the seedy glamour of this frontierlike atmosphere – still palpable today with the many bars and strip clubs along the boulevard and on the place Pigalle at the corner – that Fernande and Picasso moved in 1909, taking a large, well-lit combination apartment and studio on the top floor of this address.

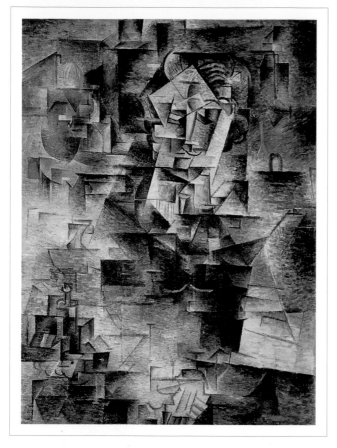

Picasso: Daniel-Henry Kahnweiler, *1910.*
The Art Institute of Chicago

ALTHOUGH HE COULD HAVE afforded to leave the Bateau-Lavoir sooner, Picasso's affection for the place had kept him there much longer. Flush times had come and gone before as dealers and collectors of one style disliked the next, but by 1909 it was clear his money troubles were over for good. In traveling down the hill, the twenty-eight-year-old artist was moving up in the world. And though the neighborhood lacked the refined elegance of some Right Bank areas, the building was an enormous improvement, deemed acceptable by no less than the great tragedienne Sarah Bernhardt, who had taken a studio for her sculpting here in the 1870s.

Aside from the canvases, however, there was not much to transport from the rue Ravignan; the old furnishings barely filled the small maid's room here. Their new accommodations were so superior that the moving men speculated that the couple must have won the national lottery. The sun-filled living quarters had a southern exposure looking out over the gardens of the beautiful little avenue Frochot; the studio boasted the shadow-free north light so prized by painters and a view of the gleaming domes of Sacré-Coeur (stop 4). Fernande enthused, "We sleep in a room that is actually intended for rest." They soon acquired a grand piano, a Louis Philippe settee upholstered in purple velvet, and a uniformed maid to serve meals at their mahogany dining table. But unlike their more conventional middle-class neighbors, they continued to amass more tribal art and the household expanded to include still more dogs, more cats, and a monkey called Mamina who had free reign of both the apartment and studio.

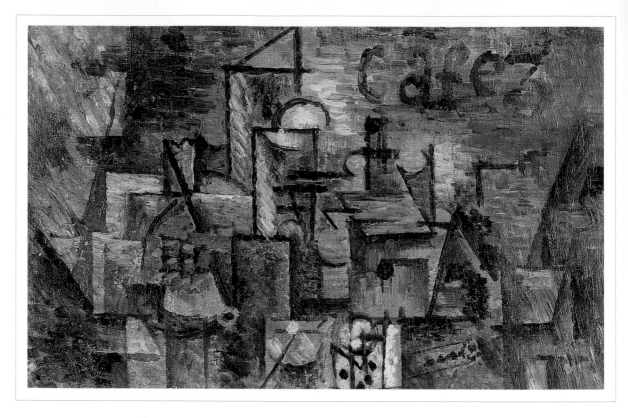

Picasso: The Pomegranate, *1911-12. Harvard University Art Museums, Cambridge, Massachusettes*

WHILE HERE PICASSO MOVED closer toward abstraction – a period Max Jacob called "the heroic age" of Cubism – than at any other time. He and Braque were now dissecting objects, reassembling them in subtle tones of browns and grays as if seen from several directions simultaneously. The two

painters worked together so closely that the excluded Fernande's jealousy further eroded her and Picasso's already shaky relationship. In his desire to escape this increasingly unhappy situation he rented another studio back at the Bateau-Lavoir and began an affair with Eva Gouel, a fragile, sickly woman he and Fernande had met with her lover, a fellow painter, at the Ermitage, their favorite brasserie on the boulevard Rochechouart.

Head west along the boulevard de Clichy to no. 130ter. Or take the métro, Line 2, diréction Porte Dauphine, two stops to Place de Clichy.

ⓒ Moulin Rouge

Opened by a former butcher in the spring of 1889 to take advantage of the crowds in Paris for the World's Fair of that year, the Moulin Rouge was an immediate hit, its lasting fame ensured by the posters and paintings of it by its most renowned habitué, Toulouse-Lautrec. Unlike the Moulin de la Galette, which once had been a real working mill, this construction was completely faux. As one observer noted, "Its sails never ground anything but the cus-

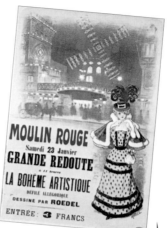

tomers' money." Picasso came occasionally although he found it too expensive and touristy, preferring the cheaper spots on the Montmartre peak.

◇◇◇

Picasso had a complicated love/hate relationship with Edgar Degas, in large part a reaction to the older artist's striking physical resemblance to the Spaniard's fair-haired father. For many years this had also been Degas's neighborhood – he lived at 37, rue Victor-Massé for twenty-two years, moving in 1912 to 6, boulevard de Clichy, across from Picasso's building, where he died in 1917.

Avenue Frochot

From his boulevard de Clichy apartment Picasso looked down on this secluded private lane, so at odds with the bustle of the surrounding streets of Pigalle. Toulouse-Lautrec moved here to no.15, close to several of his favorite diversions, the Moulin Rouge, Divan Japonais, and the Cirque Fernando (later the Médrano). He lived here until his death at age thirty-seven in 1901.

ⓓ Lux-Bar

This neighborhood bar/café near the Moulin Rouge has kept its original Art Nouveau tiles and woodwork.
12, rue Lepic. 01.46.06.05.15
Métro: Blanche

Theft of the Mona Lisa

While living at 11, boulevard de Clichy, Picasso became implicated in one of the most notorious crimes of the era, the theft from the Louvre on August 21, 1911, of its greatest treasure, *La Gioconda* (the *Mona Lisa*). The man from whom Picasso had once bought two sculpted Iberian heads, also stolen from the museum, took advantage of the public outcry to boast in one of the daily papers of his own exploits in removing artworks from the poorly guarded galleries. A panic-stricken Picasso and Apollinaire, who had brokered the Iberian purchase for his friend,

tried unsuccessfully to dump the incriminating evidence into the Seine. The poet then returned the statuettes and was detained for six days by the police on suspicion of involvement with the disappearance of the Leonardo. Picasso was also questioned and released, though he remained uneasy on the streets of Paris, convinced that he was being followed, until the painting turned up two years later in Florence. The culprit, an Italian nationalist who believed the masterpiece should be returned to its homeland, had been a framer at the Louvre.

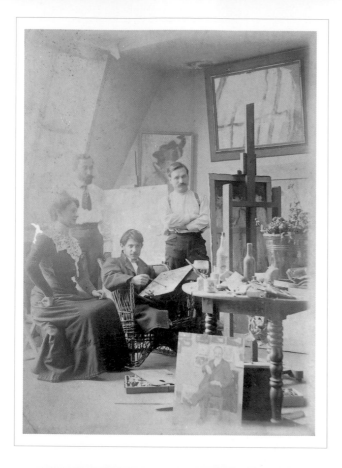

Picasso in the studio on boulevard de
Clichy, with Pere Manach (right) and
Fuentes Torres and his wife, *1901*.
Archives Picasso, Musée Picasso, Paris

STOP 7 *130ter, boulevard de Clichy*
Picasso's residence, June 1901-January 1902

Back in Spain after the first trip to Paris in 1900, Picasso's friend Casagemas, tormented by his unrequited love for Germaine Gargallo, returned, taking a top-floor studio in this building near the bustling place de Clichy. A few days later, on February 17, 1901, surrounded by friends at the Hippodrome café down the street, he pulled out a gun, fired unsuccessfully at the object of his love and then shot himself in the head. Picasso, in Paris for the second time three months later, became consumed with guilt over the suicide, an obsession fueled by his decision to live here in Casagemas's very rooms and by the affair he then began with Germaine. The ensuing depression transformed his work, as he began painting melancholy canvases completely changed from the gay pictures of Paris nightlife he had recently been producing and selling.

The Blue Room, one of the many works painted here, shows the combination studio/bedroom, which looked south over the plane trees on the center island of the boulevard de Clichy. Picasso often shared these meager accommodations with his equally impoverished friends who would spend the

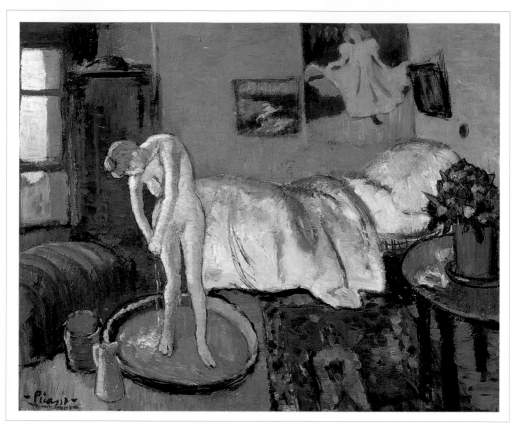

Picasso: The Blue Room, *1901. The Phillips Collection, Washington, D.C.*

night on a strip of carpet with a dictionary for a pillow. The painting still reveals the influence of Degas (the bather) and Toulouse-Lautrec (the poster of a clown-dancer that Picasso had taken down from a Montmartre wall). But both its title and cool tone point to a new, bleaker direction — the beginnings of what would come to be known as the Blue Period — years later one of the artist's most popular styles but at the time unsalable. The painting eventually fetched a mere ten francs at the junk store across from the Cirque Médrano.

BLUE — "THE COLOR OF ALL COLORS," Picasso once said — became the dominant hue and mood of the self-portrait also painted in this house. Examining the toll his despair had taken on his own features, the twenty-year-old conveys a sense of defeat unimaginable just a year earlier when he had first arrived in Paris, intoxicated with the possibilities of life.

After seven months in this studio, Picasso was so destitute he had to wire his parents for his train fare home.

End of Walk 1

ⓔ Le Wepler

Wepler on the busy *place* has been a rendezvous for generations of *montmartrois*. In the summer of 1912 Braque wrote to Picasso, who with Eva Gouel had left their romantic entanglements for a stay in the country, that while dining here he learned that Fernande was threatening to come after the couple.

14, place de Clichy. 01.45.22.53.24. Daily til 1am. Métro: Place de Clichy

At 130ter, boulevard de Clichy, Picasso was surrounded by locations associated with the most radical French art of the previous generation. The Café Guerbois, around the corner on the avenue de Clichy, had been the meeting place of the young Impressionists, most of whom lived and had studios in the immediate vicinity. The Pointillist Paul Signac had lived in Picasso's building in the late 1880s. Georges Seurat kept a studio a few doors away at no.128bis until his death in 1891.

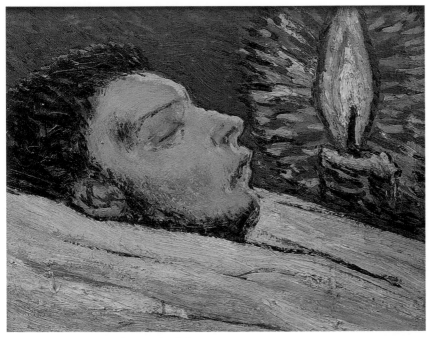

Picasso: The Death of Casagemas, *1901. Musée Picasso, Paris*

A funeral for Casagemas was held in the Montmartre Cemetery just two blocks away. Today Picasso's painted testament to his friend's tragic end can be seen at the Musée Picasso in this canvas of Casagemas' bullet-pierced head that recalls the style of van Gogh—also a suicide by gunshot a decade earlier. A painting at the Musée d'Art Moderne de la Ville de Paris imagines the dead poet's burial and ascension to heaven.

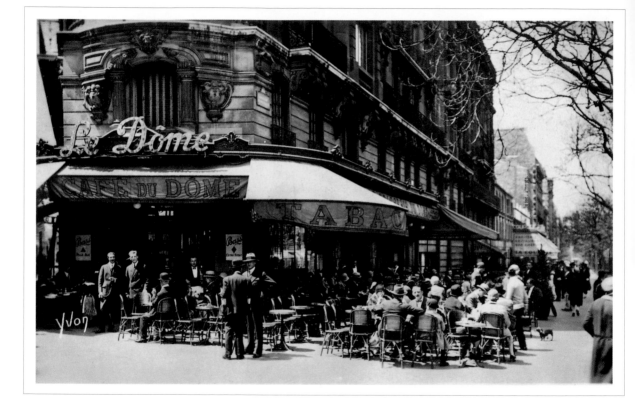

MONTPARNASSE

A T THE END OF Picasso's romantic getaway with Eva Gouel in the summer of 1912, the prospect of returning to Montmartre – Fernande's Montmartre – was more than the artist could face. He asked his dealer, Daniel-Henry Kahnweiler, to find him and his new lover new accommodations about as far away from the Butte as one could get within Paris, Montparnasse.

The relatively modern district straddled two Left Bank arrondissements, the more elegant part in the 6th from the Luxembourg Gardens to the boulevard du Montparnasse and into the less developed 14th, then an odd combination of new apartment buildings punctuated by the occasional farm.

The break for Picasso was enormous and inevitable, for the one-time penniless prodigy was now a thirty-year-old phenomenon on the brink of fame among influential European cognoscenti. Just as he had known when to leave Spain, he knew to leave the isolated village of Montmartre. The neighborhood was besieged by tourists and slumming Parisians, drawn in part by *la vie de bohème* that had initially attracted Picasso. By staking a claim in this more cosmopolitan part of town, Picasso in large part created the myth of the sophisticated urban modernist that brought about the relocation of the artistic and intellectual community – French and foreign, those already in the city as well as those who would arrive over the next few decades – and changed forever another district of Paris.

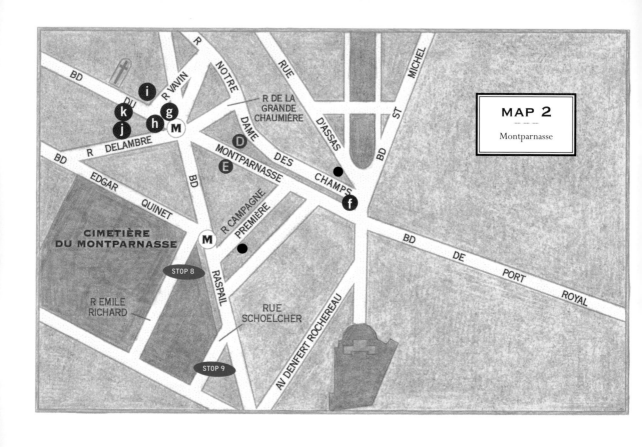

MAP 2

Montparnasse

LEGEND

STOP 8 Residence of Picasso (1912-13) – 242, boulevard Raspail

STOP 9 Residence of Picasso (1913-16) – 5*bis*, rue Schoelcher

D Residence of Fernand Léger – 86, rue Notre-Dame-des-Champs

E Residence of Henri Matisse – 132, boulevard du Montparnasse

f La Closerie des Lilas – 171, boulevard du Montparnasse

g La Rotonde – 105, boulevard du Montparnasse

h Le Dôme – 108, boulevard du Montparnasse

i Le Select – 99, boulevard du Montparnasse

j Auberge de Venise – 10, rue Delambre

k La Coupole – 102, boulevard du Montparnasse

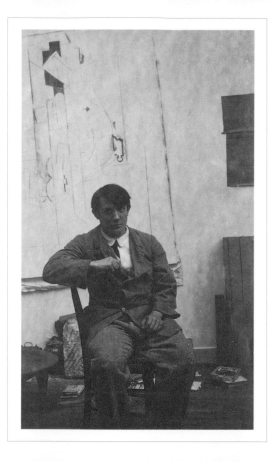

Picasso: Self-Portrait in front of
"Construction with a Guitar Player,"
boulevard Raspail studio, *1913.*
Archives Picasso, Musée Picasso, Paris

No. 242, boulevard Raspail
Picasso's residence, 1912-1913

Métro: Raspail

(The artist lived at the back of the building, which can be seen from the northeast corner of the Montparnasse Cemetery,
accessible around the corner from the rue Émile Richard and through the first gate on the left)

MONTPARNASSE BOASTED SCORES OF large inexpensive ateliers, especially the ground-floor accommodations preferred by sculptors who did not need the even north light of a painter's garret and did not want to carry their heavy materials up and down flights of stairs. It was in such a space that Picasso and Eva Gouel lived, on the street level of a studio complex named for the great seventeenth-century French painter Nicholas Poussin. Their quiet apartment was at the rear, where they could reach out and touch the headstones of the adjoining Montparnasse Cemetery.

Although this portion of the boulevard Raspail had been open about 150 years when Picasso moved here, the neighborhood had only recently become easily accessible from other parts of the city. The extension of the street north of the boulevard du Montparnasse to the center of Paris, the

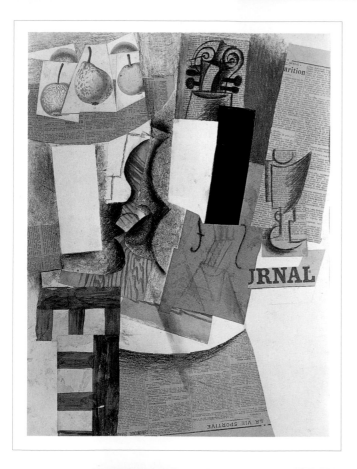

Picasso: The Violin and Compote of Fruit,
1913. Philadelphia Museum of Art

completion in 1910 of the Montmartre-Montparnasse métro line, and the installation of electric streetcars, which ran right past Picasso's new studio, made the quarter more appealing. The couple's

living quarters were well kept, with fine silk brocade draperies and comfortable upholstered armchairs, but they found the place too dreary and stayed only a year. In his short time here, though, Picasso embarked on some of the most important work of his career — revolutionary three-dimensional constructions, such as the guitars he assembled from sheets of metal and cardboard wired together, and the ground-breaking Cubist collages, the *papiers collés*. All the accoutrements of these new creations — cut up newsprint, shreds of *tromp-l'oeil* wallpaper, letter stencils, India ink, and pots of glue — were now added to the usual extraordinary clutter of his previous workplaces.

Walk south along the boulevard Raspail to the next corner, turning right into the rue Schoelcher, stopping opposite no. 5bis.

Cimetière du Montparnasse

At almost fifty acres, this is the second largest cemetery in Paris. Built in 1824, many artists and writers chose to be buried here, including several who came within Picasso's orbit. Look for Brancusi's *The Kiss* of 1910 in the extreme northeast corner near the back wall of Picasso's building. Tristan Tzara, the Dada leader, is buried in division 8 on the western side of the cemetery. The graves of Jean-Paul Sartre and Simone de Beauvoir, associates of Picasso's in the later years in Saint-Germain-des-Prés, are together, in division 20 beside the boulevard Edgar Quinet.

◇◇◇

The quarter's name — the Mount of Parnassus, domain of Apollo and the Muses — had been bestowed by Latin Quarter students long before the area was annexed to Paris in the beginning of the eighteenth century. It referred to a hill — actually a man-made pile of rubble that may have come from the construction of the nearby catacombs — that was levelled before the Revolution when the boulevard was put through.

Rue Campagne Première

When Picasso and Casagemas emerged from the Gare d'Orsay upon their arrival in Paris in 1900, they set off for 8, rue Campagne Première to rent a friend's vacant studio. They left a deposit and their bags and headed up to Montmartre to see their Catalan compatriots who had settled there. Immediately realizing that it, and not Montparnasse, was the place to be, they recrossed the city to retrieve their possessions and at least part of their money.

A dozen years later, Picasso returned to live on the boulevard Raspail in a building opposite the end of this very street. What he had once considered a cultural backwater was quickly becoming the very center of the avant-garde art world, something his own renown greatly encouraged. Many noted Montparnasse artists eventually worked in the 1911 studio building at 31-31 *bis*, rue Campagne Première, including Kandinsky, Miró, Calder, Ernst, Giacometti, and Man Ray — for a time Picasso's exclusive photographer — who lived here with his mistress, model, and muse, Kiki of Montparnasse.

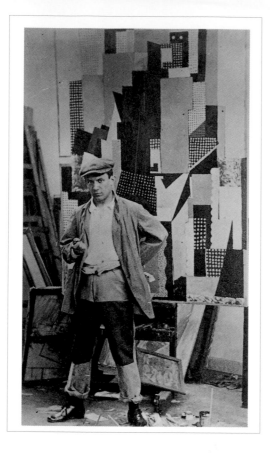

Picasso: Self-Portrait with "Man Leaning on a Table" in Progress, rue Schoelcher studio, *1915-16. Archives Picasso, Musée Picasso, Paris*

No. 5bis, rue Schoelcher
Picasso's residence, 1913-1916

I N THE AUTUMN OF 1913, Eva found larger, more cheerful accommodations just around the cor- ner at 5*bis*, rue Schoelcher, a side street a bit farther from the action on the boulevard du Montparnasse and therefore even more tranquil. This much grander modern building was designed for well-heeled bohemians and featured plaster casts of the Elgin Marbles lining the carpeted stair- ways. Picasso's atelier, which was likened to a large church, had an enormous bay window that looked out over the Jewish section of the Montparnasse Cemetery, flooding their rooms with sunlight.

Despite the improved surroundings, Eva's always fragile health was worse than ever. This depressing domestic situation was reflected in the city as a whole during the six months following their move here as war with Germany became increasingly probable. The formal declaration of hos- tilities in the summer of 1914 set in motion a sequence of events that would completely disrupt Picasso's life, as it would the lives of millions of others. Soon there would be major changes in his friends, lovers, collaborators, as well as in the part of the city where he would reside – all reflected,

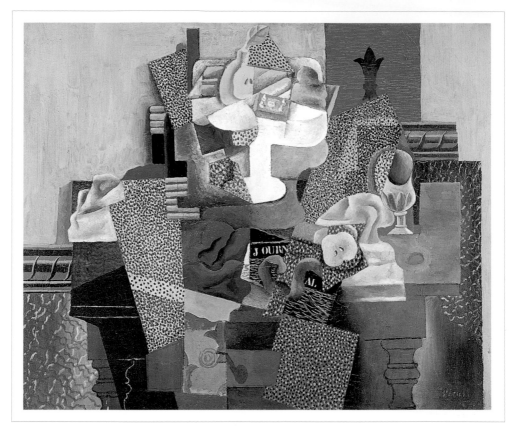

Picasso: Still Life with Compote and Glass, *1914-15. Columbus Museum of Art*

of course, by major changes in his work.

Braque, Derain, Léger, and Apollinaire were among those who enlisted immediately, leaving Picasso, a citizen of neutral Spain, nearly alone in the almost deserted city. Then business for all of Kahnweiler's artists came to a halt when the contents of the German dealer's gallery were seized as property of an enemy alien. In late 1915, a miserable Picasso wrote to Gertrude Stein that he spent most of his time in the métro going to visit Eva, now confined to an overcrowded and understaffed wartime clinic on the outskirts of Paris. She died there, probably of cancer, on December 14th. The painful memories and ever-present reminder of all those headstones meant that staying on at the rue Schoelcher was now impossible. And because Picasso felt so conspicuous as an able-bodied civilian in the feverishly patriotic, mobilized Paris – whose streets Gertrude Stein described as "menless" – he removed himself to a small private house in Montrouge, a quiet suburb south of Montparnasse, remaining there until yet another major change sent him elsewhere still.

Turn left back onto the boulevard Raspail, continuing to the rue de Fleurus (see map on page 90). Turn right and stop at no.27. Or enter the métro at the Raspail station on the boulevard, taking line 4, diréction Porte de Clignancourt, three stops to Saint Placide. From the rue Notre-Dame-des-Champs turn left onto the rue de Fleurus to no.27.

Jean Cocteau

The elegant twenty-seven-year-old poet, playwright, and darling of the Parisian elite, Jean Cocteau knew there was a lot more happening beyond the confines of the staid Right Bank than within it. He set about meeting the exotic avant-gardists of Montparnasse, who were as geographically, culturally, and socially isolated in their little corner of the Left Bank. The ambitious Cocteau wanted to be the figurative bridge across the Seine who would bring these two distant communities together. Through a series of introductions, he was taken to the rue Schoelcher to see Picasso — "the encounter of my life," he would proclaim from then on, a meeting that would also have a

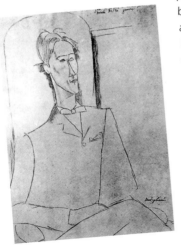

profound impact on Picasso and on the eventual acceptance of radical art by mainstream Paris. Cocteau, who had served in the war effort as an ambulance driver, took advantage of an adrift Picasso — still mourning Eva, lonely for his friends at the front, anxious for diversion — and persuaded him to collaborate on a new production for Sergei Diaghilev's renowned Ballets Russes. Picasso was to design the sets and the costumes for the work, with music by Erik Satie, choreography by Leonid Massine, and the scenario by Cocteau himself. *Parade*, the story of barkers on a Parisian boulevard trying to lure passers-by into a circus tent, brought Picasso to the attention of a whole new audience and introduced him to his future bride, Olga Koklova, a dainty Russian dancer in the corps de ballet. Just as Picasso was making it chic for Paris society to be seen at the carrefour Vavin cafés and to have their portraits painted by one of the moderns of Montparnasse, he once again decided that it was time to move on.

Amedeo Modigliani: Jean Cocteau, *1916. Collection Comité Cocteau*

D Residence of Fernand Léger

Like Picasso, Léger first arrived in Paris in 1900 at the age of nineteen. For a time he lived at the notorious La Ruche ("The Beehive")—a sort of Bateau-Lavoir for impoverished Left Bank artists—that had been the wine pavilion at the 1900 Exposition Universelle and was re-erected in the 15th arrondissement near Montparnasse. In 1913 Léger took a huge studio at 86, rue Notre Dame-des-Champs that backed onto the boulevard du Montparnasse, where he worked for more than four decades until his death in 1955. This long curving street contained more studios than any other in the city.

E Residence of Henri Matisse

Matisse, who divided his time between Nice and Paris after World War I, took a sixth-floor apartment at 132, boulevard du Montparnasse in 1930.

Studio of Frédéric-Auguste Bartholdi

Bartholdi worked on scale models for his monumental Statue of Liberty at 40, rue Vavin, in one of Montparnasse's many sculpture studios. This part of the street was demolished when the boulevard Raspail was extended north early in the century.

One month into the war thousands of French troops were transported to the front in 5000 requisitioned Paris taxis when German units advanced within sight of the Eiffel Tower. Four years later, in 1918, assaults by the German railway gun dubbed Big Bertha inflicted the worst damage the capital suffered when a shell hit the church of Saint-Gervais on Good Friday, killing and wounding 175 people.

Amedeo Modigliani

The son of an impoverished family of Italian Jews, the handsome, turbulent Modigliani first lived in Montmartre after arriving in Paris in 1906, where his band of associates and Picasso's rarely mixed. He, too, relocated to Montparnasse in the Teens, eventually taking a studio at 8, rue de la Grande-Chaumière, in a building where Gauguin, one of his heros, had lived nearly twenty-five years earlier when he had returned to Paris from Tahiti. Always short of supplies, Modigliani once carved heads from wooden railway ties he had stolen from the construction of a métro station. Some mornings he would arrive at La Rotonde to sell his drawings until he had earned enough to sit and drink for the rest of the day. If this failed, like many other artists, he was welcome to pay his tab with his paintings. As fellow foreign noncombatants in deserted, wartime Paris, Picasso and Modigliani often sought out one another at the Rotonde, much improving the latter's stature in the avant-garde community. Within a short time, however, the years of dissipation caught up with Modigliani, who died in the pauper's ward of a hospital at thirty-six in 1920, never seeing the success of his distinctive, distorted figures. His friends took up a collection in the cafés to pay for a lavish funeral and burial at Père Lachaise.

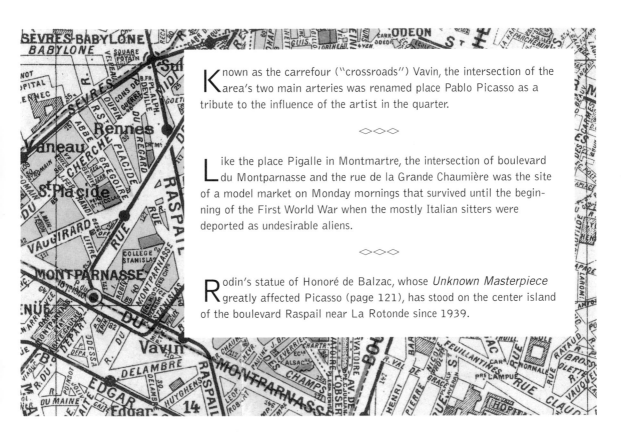

Known as the carrefour ("crossroads") Vavin, the intersection of the area's two main arteries was renamed place Pablo Picasso as a tribute to the influence of the artist in the quarter.

◇◇◇

Like the place Pigalle in Montmartre, the intersection of boulevard du Montparnasse and the rue de la Grande Chaumière was the site of a model market on Monday mornings that survived until the beginning of the First World War when the mostly Italian sitters were deported as undesirable aliens.

◇◇◇

Rodin's statue of Honoré de Balzac, whose *Unknown Masterpiece* greatly affected Picasso (page 121), has stood on the center island of the boulevard Raspail near La Rotonde since 1939.

The Cafés of Montparnasse

Although Montparnasse lacked the picturesque charm of Montmartre, it initially offered a respite from the ceaseless whirl of those early days that some artists had begun to outgrow; it was "a haven of freedom and beautiful simplicity," declared Apollinaire. Of course there were still cafés; the boulevard du Montparnasse, like the boulevard de Clichy, once had been just outside the tax collector's wall, with many bars and cabarets established along it offering wine that was less expensive than elsewhere in Paris.

During Picasso's time in the neighborhood and for decades to come, the cafés that face one another across the boulevard du Montparnasse at the juncture of the boulevard Raspail were both the geographic and social heart of the district, "sidewalk academies where one learns bohemian life and scorn for the middle class." Artists and models, writers and editors, everyone came to the big cafés for solace and inspiration, both to conduct business and to begin or end love affairs. Newly arrived Americans in Paris came directly from dropping their bags at their hotels. It was said that a quick word to an acquaintance at a Montparnasse café was a more effective way of disseminating information than taking out an ad in the paper. Although some groups were more associated with one café than the others, most *montparnos* simply table-hopped from one place to another, often crossing the boulevard several times in the course of an evening.

If the large cafés brought artists together during the winters of the First World War when few other places had heat, it was the presence there of the German occupying forces during World War II – turning their sidewalk terraces into a "sea of green" – that finally dispersed most of the Montparnasse avant-garde community. The closing of the Vavin métro station during the war was a further deterrent, sending most of the old regulars to the more centrally located cafés of Saint-Germain-des-Prés (see stop 12).

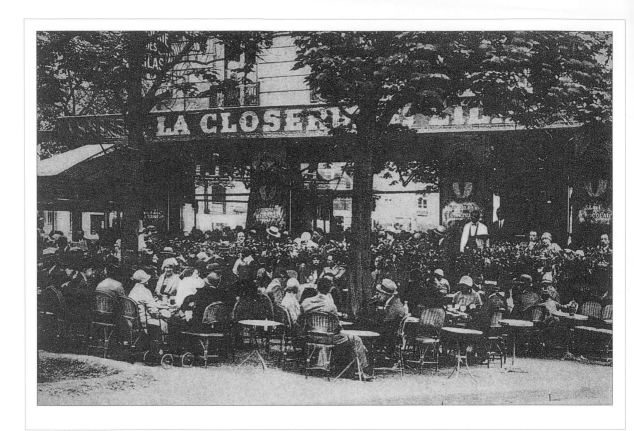

ⓕ *La Closerie des Lilas*

Located at the eastern end of the boulevard du Montparnasse on the border of the Latin Quarter, this café/restaurant/bar that opened in 1850 was named for the lavender and white lilac arbors that once grew here. It was always popular with native and foreign writers, including Baudelaire, Chateaubriand, Zola, and Henry James. This literary tradition continued into the early years of the twentieth century when poets Max Jacob, Guillaume Apollinaire, and André Salmon, often accompanied by Picasso, traveled across the city from Montmartre to attend weekly Tuesday night readings and discussions that usually ended as drunken brawls. During the 1920s Ezra Pound, John Dos Passos, F. Scott Fitzgerald, and James Joyce came alone and together. Ernest Hemingway, who lived over a sawmill around the corner at 113, rue Notre-Dame-des-Champs, wrote much of *The Sun Also Rises* at the Closerie.

171, boulevard du Montparnasse. 01.43.26.70.50. Daily noon-2am. Métro: Port Royal

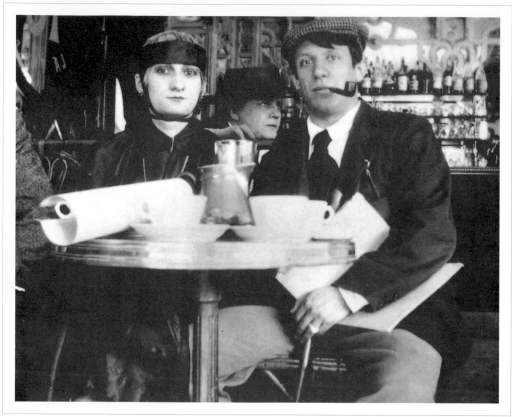

Jean Cocteau: Picasso and Paquerette at La Rotonde, *1916*

g *La Rotonde*

La Rotonde was only open a year when Picasso arrived in the neighborhood. At that time, the café was a favorite of the exiled Trotsky and Lenin, who were replaced after the Revolution by White Russian refugees. Although the terrace here has always been popular because it gets the afternoon sun, it was the smoke-filled back room that was reserved for the regulars. Regarding his introduction here, Jean Cocteau quipped: "Picasso keeps taking me to La Rotonde. I never stay more than a moment, despite the flattering welcome given me by the circle (perhaps I should say the cube)."

In her memoirs, Kiki recalled that many artists set up housekeeping with items they brought home from the Rotonde. At a party in his studio, an embarrassed Modigliani once served dinner to the café's owner with dishes and silverware pilfered from the restaurant. American expatriates of the Twenties largely boycotted the place because of the nasty treatment they received from the then owner, who denied service to women who smoked or went hatless.

105, boulevard du Montparnasse. 01.43.26.68.84. Daily 8am-2am. Métro: Vavin

h *Le Dôme*

Le Dôme, which opened in 1897, is the oldest of the four famous carrefour Vavin cafés, and has always been known as the one for serious drinking. In its early years the front room was the headquarters for German artists in Paris, who came to be known as *dômiers* from their time spent here; the American literary colony, in its greatest numbers in the 1920s, congregated in the back room. By the 1930s, it was said that the international fame of the café meant one could overhear every language on earth being spoken on the crowded sidewalk *terrasse*. Arriving in Paris at the start of the Depression, a broke Henry Miller would often sit at one of the little marble-topped tables here or at La Rotonde, order a café au lait and a sandwich, and simply wait until a friend willing to pay his tab would come along. Kiki, the undisputed queen of Montparnasse, had a table on permanent reserve.

108, boulevard du Montparnasse, 01.43.35.34.82. 8am-1am; closed Mon. Métro: Vavin

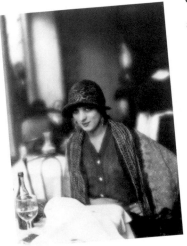

Kiki at a Montparnasse café.
Photo by Man Ray

ⓘ Le Select

Brassaï lived in this building shortly after the Select opened in 1925, the first Montparnasse café to stay open all night. Today it is the least changed of the four around the carrefour Vavin. 99, boulevard du Montparnasse. 01.45.48.38.24. Daily 8am-3am Métro: Vavin

ⓙ Auberge de Venise

The restaurant has changed hands several times since the heyday of Montparnasse but none of its owners has done away with the orignal bar and six stools, where Picasso and Cocteau sat when the premises were known as the Dingo Bar. This was also a favorite hangout of Hemingway and Fitzgerald, two of the most notorious drinkers of the period. In 1926, Isadora Duncan lived in the studio hotel at 9, rue Delambre across the street. 10, rue Delambre. 01.43.35.43.09. Métro: Vavin

ⓚ La Coupole

Opened during the *années folles,* the reckless, carefree years in Paris between the Armistice and the Depression, La Coupole, a relative "newcomer" on the boulevard, is now a historic monument, with columns decorated by area painters. The enormous space was billed as the largest café in the city. Josephine Baker and other expatriates – Joyce, Hemingway, Fitzgerald, Henry Miller, and Man Ray – felt particularly at home here. 102, boulevard du Montparnasse 01.43.20.14.20. Daily 8am-2am Métro: Vavin

MAP 2A

Luxembourg Quarter

LEGEND

STOP 10 Residence of Gertrude Stein (1904-38) – 27, rue de Fleurus

F Residence of Picasso (1918) – Hôtel Lutetia, 45, boulevard Raspail

l La Méditerranée – 2, place de l'Odéon

m Polidor – 41, rue Monsieur-le-Prince

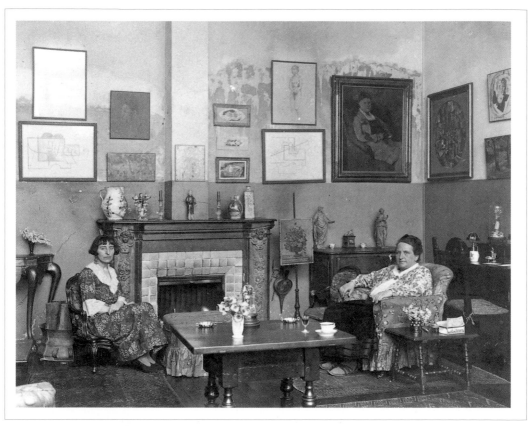

Man Ray: Alice B. Toklas and Gertrude Stein, rue de Fleurus, Paris, *1922. The Baltimore Museum of Art*

27, rue de Fleurus
residence of Gertrude Stein, 1904-1938

FOR MANY YEARS, THE little two-story pavilion at the back of the courtyard and the detached, single-story studio beside it was the only place in Paris to see the most radical contemporary art. Here, on a modest income, Gertrude Stein and her brother Leo amassed a collection that hung four or five deep on every available wall, including works by Cézanne, Renoir, Gauguin, Derain, Gris, Matisse, and Picasso — Blue Period, Rose Period, and Cubism.

During the Great War, Gertrude Stein was one of the few close friends of Picasso who remained in Paris. Because the two now lived so close to one another, they spent more time together than they had since 1906, when the thirty-two-year-old Gertrude had traveled almost daily to the Bateau-Lavoir across the city — in a horse-drawn bus from the place de l'Odéon to the place Blanche and then up the steep hill on foot — for some ninety sittings for her portrait. Although they would argue about the recent Spanish-American War, Picasso felt relaxed with Mademoiselle Gertrude, who also spoke French poorly and with a strong accent.

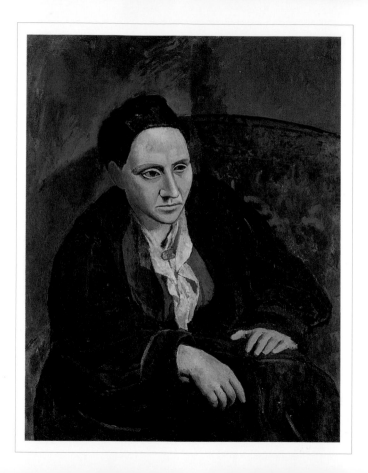

Picasso: Gertrude Stein, *1905–06.*
The Metropolitan Museum of Art, New York

For the portrait Picasso placed his subject, wearing her customary outfit of loose brown corduroy and a favorite coral brooch, in his broken-down armchair, all but concealed behind her girth. After several months of work, however, the frustrated artist wiped out the unsuccessful head, and left for his summer vacation in Spain. Returning to the picture in the fall, and without benefit of his subject before him, he recast Gertrude's features like those of the ancient Iberian sculptures that so preoccupied him at the time.

Some evenings during the sittings Picasso and Fernande would accompany Gertrude back home and stay on to dinner, a routine that would evolve into the famous Saturday night salons. These became the first stop for many American writers and artists arriving in the city, the place where they were introduced to the members of the Parisian avant-garde, who, as in the case of Picasso and Matisse, often were meeting one another for the first time here as well. The hostess referred to her visitors as "geniuses, near geniuses, and might be geniuses."

In *A Moveable Feast* Ernest Hemingway likened the rue de Fleurus studio to "one of the best rooms in the finest museum except there was a big fireplace and it was warm and comfortable and they gave you good things to eat." At dinner, with each artist seated in front of his own works, the guests might be served a soufflé, the specialty of Hélène, the maid, or chicken fricassee and corn bread prepared by Alice Toklas, who began living here in 1910.

After the war, when the two American women had worked delivering medical supplies in their

car "Auntie" to French troops, the Saturday nights were not revived as so many of their old friends and admirers had dispersed: Apollinaire was dead, Matisse gone to the South of France, Picasso married and living amid the swells of the elegant Right Bank. "Paris," Alice noted on their return, "like us, was sadder than when we left it." They still received a steady stream of visitors – now more writers than painters – some by appointment, some bearing letters of introduction. But the time when this was one of the most important addresses in avant-garde Paris had passed.

Gertrude, whose monklike attire rarely escaped comment, had always advised people, "you can either buy clothes or buy pictures. It's that simple." By the mid-1920s, however, the woman who

had been one of the first patrons of the modern artists was still an unknown writer and could no longer afford their works. But her early purchases of the Picassos that helped launch his career later allowed her to profit from his success – she reluctantly sold one to finance the publication of *The Autobiography of Alice B. Toklas* – and finally to launch her own.

End of Walk 2

Luxembourg Gardens

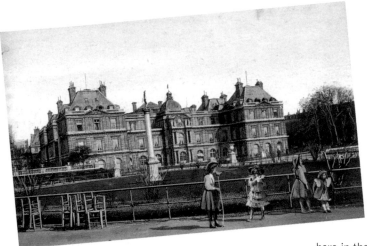

At the eastern end of the rue de Fleurus lies the Luxembourg Palace and its sixty-acre gardens, built in the early seventeenth century by Marie de Medici. Gertrude Stein walked her standard poodle Basket in this largest green space on the Left Bank, no doubt feeling at home among the statues depicting the queens of France and other renowned women.

During the Great War, when Victory Gardens were started all over Paris, string beans and carrots were grown here in the normally manicured plots. From 1818 until the Second World War, the Orangerie of the Luxembourg housed the works of living and recently deceased French artists, which Picasso came to see when he first arrived in Paris. Parts of the collection were transferred first to the Jeu de Paume and then to the Musée d'Orsay, where they are displayed today.

Trying out the new north/south métro on an outing to Marie Laurencin's in Montmartre, a claustrophobic Gertrude Stein insisted on getting off at the first stop to take a cab instead. "The métro," Alice Toklas recalled, "was not to be an experience for us."

F Hôtel Lutetia

Following their engagement in the spring of 1918, Picasso's status-conscious fiancée Olga Koklova had no interest in living in the artist's déclassé suburban Montrouge home nor among even the monied bohemians of Montparnasse. The couple took a large suite at the elegant new Lutetia, where Picasso even had a studio, while their grand apartment on the Right Bank was readied for them. On November 11th, just two days before the Armistice, the artist received word at the Lutetia that his dear friend Guillaume Apollinaire, in a weakened state since a serious head wound in battle, had died in the influenza epidemic.

45, boulevard Raspail
01.49.54.46.46
Métro: Sèvres-Babylone

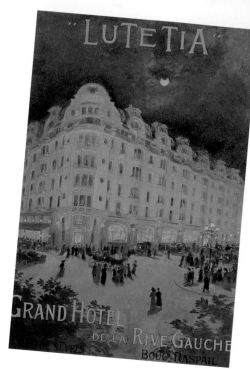

◇◇◇

The woman who once remarked, "America is my country and Paris is my home town," returned to the States during her first year in France and then just once again in 1934 for a lecture tour to promote *The Autobiography of Alice B. Toklas.*

❶ La Méditerranée

Picasso and Cocteau – whose drawings still
illustrate the menu – often dined here after the
seafood restaurant opened in the 1930s.

2, place de l'Odéon. 01.43.26.46.75
Daily til 11pm. Métro: Odéon

ⓜ Polidor

Generations of Parisians have dined on the simple bistro classics at Polidor in its
150 years on the border between Saint-Germain and the Latin Quarter.

41, rue Monsieur-le-Prince. 01.43.26.95.34. Mon-Sat noon-2:30pm, 7pm-1am;
Sun noon-2:30pm, 7-11pm. Métro: Odéon, Luxembourg, or Cluny

Gertrude Stein would say of her portrait, "...for me, it is I." Picasso had given
her the picture, she reported years later, when "the difference between a sale
and a gift was negligible." In her will, this was the only of her paintings that she
bequeathed to a museum, the Metropolitan in New York. A few days before it was
to be shipped from the women's apartment on the rue Christine (see page 130),
Picasso came to bid farewell to the work he had created forty years earlier, predict-
ing to Alice Toklas that neither of them would ever see it again.

After she published
Ulysses, Sylvia
Beach, owner of
Shakespeare and
Company at 12, rue de
l'Odéon, fell out with
Gertrude Stein, who liked
to quote Picasso that
Joyce was "an incompre-
hensible whom anybody
can understand."
Hemingway noted that if
you brought up the Irish
writer's name more than
once at the rue de
Fleurus, you would not be
invited back. Shakespeare
and Company was closed
in 1941 during the
German Occupation when
a Nazi officer threatened
to confiscate the contents
of the shop.

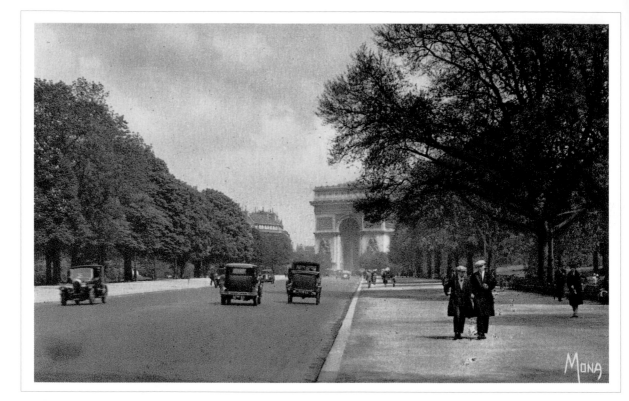

WALK 3
ÉTOILE QUARTER

I T WAS NOT UNTIL the early 1930s that the Champs-Élysées became a dazzling commercial strip. Before then it had been a quiet residential avenue of aristocratic gentlemen's clubs and stately private mansions. The streets of the surrounding Étoile quarter were the province of stylish cafés, exclusive apartment buildings, and luxury boutiques. Also setting up shop in the posh eighth arrondissement were a number of the more distinguished art galleries that wished to attract both the affluent residents of the district as well as the monied tourists staying in its opulent grand hotels.

Picasso's new dealer, Paul Rosenberg, was among them, moving to the rue La Boëtie, a long, busy street that runs through the most elegant shopping district in Paris, commanding record highs for the newly chic Modern masters. Once Picasso and Olga were married on July 12, 1918 in an opulent ceremony at the Russian Orthodox Church on the rue Daru, the socially ambitious bride of the most talked about painter in town required a home where they could receive the fashionable friends now courting them. Rosenberg strategically placed the newlyweds in the building at 23, rue La Boëtie, right next to his gallery at no. 21. After years living on the marginalized fringes of the city, the middle-aged Picasso — now at the center of official, worldly Paris — had truly arrived.

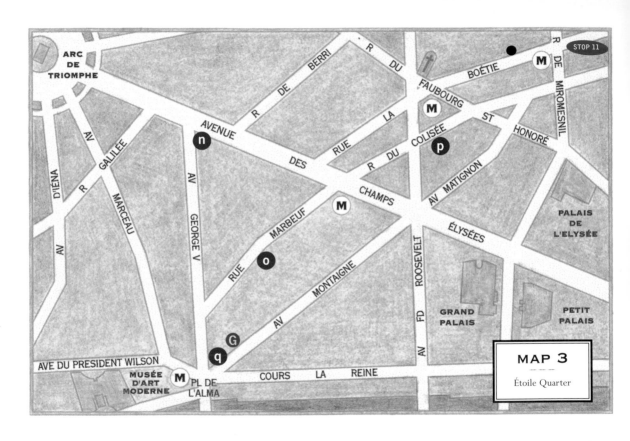

ARC
DE
TRIOMPHE

R DE BERRI

R DU FAUBOURG

BOËTIE

STOP 11

M

M

AVENUE

RUE

LA

M

COLISÉE

p

R DE MIROMESNIL

ST

HONORÉ

AV GALILÉE

R MARCEAU

AV D'IENA

AV

GEORGE V

AV

n

DES

CHAMPS

R DU

AV MATIGNON

M

RUE

MARBEUF

M

o

ÉLYSÉES

PALAIS
DE
L'ELYSÉE

AV MONTAIGNE

FD ROOSEVELT

AV

G

q

GRAND
PALAIS

PETIT
PALAIS

AVE DU PRESIDENT WILSON

MUSÉE
D'ART
MODERNE

M

PL DE
L'ALMA

COURS LA REINE

MAP 3
- - -
Étoile Quarter

LEGEND

STOP 11 Residence of Picasso (1918-1942) – 23, rue La Boëtie

G Théâtre des Champs-Élysées – 15, avenue Montaigne

n Fouquet's – 99, avenue des Champs-Élysées

o Chez André – 12, rue Marbeuf

p Le Boeuf sur le Toit – 34, rue du Colisée

q Chez Francis – 7, place de l'Alma

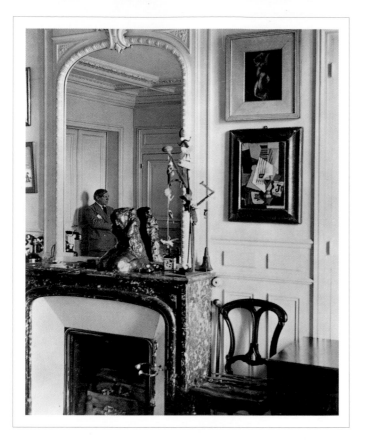

Brassaï: Picasso in the mirror,
rue La Boëtie, *1932-33*

243, rue La Boëtie, Picasso's residence 1918–1942

Métro: Miromesnil

P AUL ROSENBERG TOOK FULL advantage of Picasso's proximity here, often shouting up from the sidewalk outside his gallery to ask the artist's opinion about a potential acquisition. Similarly, Picasso would call down to show his dealer what he was working on. As he had at the Bateau-Lavoir, Picasso took two apartments here, with the living quarters on the sixth floor and the studio up one flight under the eaves, reached by an elevator, a convenience unknown at his previous addresses. The imposing limestone building, like so many in the neighborhood, featured decorative carvings and ornate wrought iron balconies on its facade. The front windows faced toward the enormous dome of the nearby Saint-Augustin, which made its way into many of the views Picasso painted during this period. Each of the large, beautifully proportioned rooms had a marble fireplace; there was a concert grand piano, fine antiques, and expensive satin upholstery. A uniformed staff included a liveried chauffeur to drive the Picassos in their enormous black Hispano-Suiza to the seventeenth-century villa they had bought outside Paris in the village of Boisgeloup. The artist who had once dressed in a

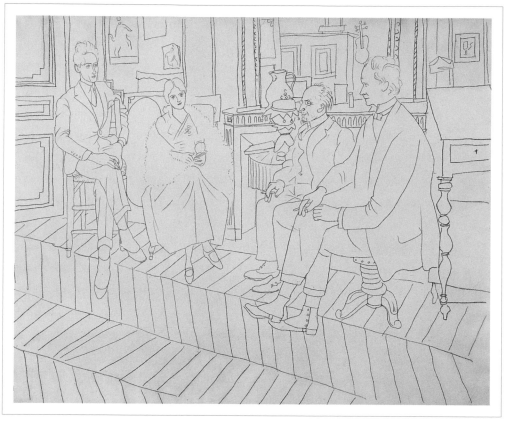

Picasso: Olga's Salon (Cocteau, Erik Satie, and Clive Bell), *1921. Musée Picasso, Paris*

singe ("monkey-suit"), the traditional blue laborers' coveralls, now had his suits custom-made; his watch was gold, his dogs pedigreed Russian wolfhounds. Finished paintings were no longer haphazardly propped against every surface as in the early Montmartre garrets, but encased in elaborate gilded frames that hung along with his growing collection of Rousseaus, Matisses, Cézannes, Renoirs, and Corots, some of which he bought, some of which he traded for his own work. In several drawings of the apartment that Picasso rendered in the more realistic, neoclassical style he had adopted during the war, he stresses the overwhelming whiteness of his wife's prim, impersonal decor and the extreme order of the household. On the studio floor, where Madame Picasso was not welcome, the rooms were entirely empty of all conventional furnishings and, in great contrast to the noble surroundings, filled with all of Picasso's customary filth and clutter. All the doors had been removed to make for one enormous space that was subdivided into various work and storage areas. The photographer Brassaï described what was meant to be the living room of this second apartment, which Picasso had transformed into the painting studio: "The window faced south, and offered a beautiful view of the rooftops of Paris, bristling with a forest of red and black chimneys, with the slender, far-off silhouette of the Eiffel Tower rising between them."

LIKE MANY PEOPLE IN postwar Paris, Picasso seemed caught up in frenzied search for release from the catastrophe that had been the Great War. With so many hundreds of thousands dead, nearly every-

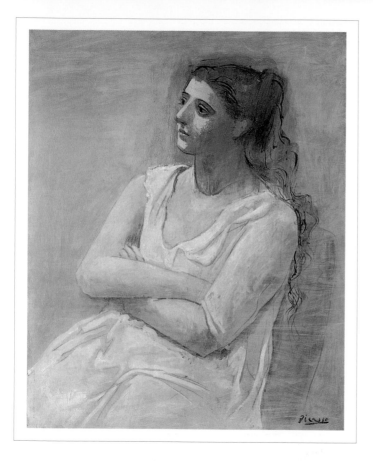

Picasso: Woman in White (Sara Murphy),
1923. The Metropolitan Museum of Art, New York

one had lost someone dear to them. Maimed and shell-shocked veterans and widows in black had become a constant reminder on the streets of the city. As the Picassos settled into their new life on the rue La Boëtie, they received invitations to the elegant dinners given by all the great society hostesses, attended the glittering balls, amused themselves at the most important opening nights at the theater and ballet, danced the Charleston, sipped champagne and ate caviar in the glamorous new jazz clubs. Here in the most privileged of the *beaux quartiers* during this Golden Age of self-indulgence, of blotting out the past and reveling in the present, the once scruffy and gauche social outcast had picked a thrilling time and place to be rich and famous. The constant whirl of their social engagements may have also temporarily distracted the couple from the significant differences in their backgrounds, temperaments, interests, and goals – differences that eventually and irrevocably would come between them.

IN THE MEANTIME, THEY lived *le high life* both in town and country, summering at the chic seaside resorts in Deauville, Dinard, and all along the Riviera, where in 1921, shortly after the birth of their only child, Paulo, they were introduced to the wealthy Gerald and Sara Murphy. Like Ernest Hemingway and F. Scott Fitzgerald – who modeled the Divers of his *Tender is the Night* on the glamourous expatriate couple – Picasso was intrigued by the sensitive, beautiful American. And like so many of the women in his life, Sara Murphy entered the artist's work, in some of the most ethereal

portraits of his Classical period.

On a bitter cold day in January 1927, a chance encounter on the boulevard Haussmann would result in a new relationship, a new child, and a whole new direction for Picasso's art. Intrigued by a young blonde outside the Galleries Lafayette department store a few blocks from his apartment, the forty-five-year-old painter approached her, declaring, "Mademoiselle, you have an interesting face. I would like to make your portrait. I am Picasso." The seventeen-year-old Marie-Thérèse Walter did not recognize the famous name but she agreed to another meeting two days later at the nearby Saint-Lazare métro station. The two became lovers and soon this new muse's bobbed hair, round face, and curvaceous body began to invade Picasso's work in the form of sensual lines, biomorphic shapes, and a luscious palette of pinks, yellows, greens, and lavenders.

By the fall of 1930, he installed his new mistress in an apartment just down the street at 44, rue La Boëtie. Although he and Olga did not divorce – Picasso's Spanish citizenship forbid it and he refused to relinquish half of his substantial assets to a woman he now abhorred – the faltering marriage was effectively over when she learned of Marie-Thérèse's pregnancy in 1935 and moved to the Hôtel California a few blocks away on the rue de Berri.

DESPITE PICASSO'S REPEATED claim that he wished "to live like a poor man with a great

deal of money," that although he never again wanted to experience the privations of those early years in Paris, he was really a simple man who enjoyed simple pleasures. During his time on the Right Bank, however, Picasso lived like a rich man with a great deal of money. This may explain the paradox that although he spent more than twenty years residing in this neighborhood, longer than he had in Montmartre and Montparnasse combined, the Élysée quarter seems the least touched by his presence. The earthy, vital Spaniard never really belonged in these rarefied surroundings, nor could the frivolous pursuits of the beau monde hold his attention forever.

End of Walk 3

Coco Chanel

The famed *couturière* joined Cocteau and Picasso as the costume designer for the 1920s Diaghilev productions of *Antigone* and *Le train bleu*. Chanel was "swept up by a passion" for Picasso, who called her "the most sensible woman in Europe." The two identified with one another — kindred spirits whose talent had allowed them to rise above humble beginnings to the heights of their respective professions. Chanel kept a room in her lavish apartment at 29, rue du Faubourg-Saint-Honoré for Picasso's sole use whenever he did not feel like staying at his country estate or at his own city address.

n Fouquet's

Though not a full-fledged historic monument, Fouquet's is listed as a *lieu de mémoire*, a place of importance in the city's collective memory. When it opened one year into the twentieth century, it was the first restaurant on the Champs-Élysées. Today, ironically, it is the last chic dining spot in a sea of fast-food outlets and tourist-trap cafés. For years, James Joyce, who lived nearby on the rue Galilée, ate here nightly.

99, avenue des Champs-Elysées, 01.47.23.70.60
Daily 8:30am-12:30am. Métro: George V

◇◇◇

Picasso, like Matisse, was so wealthy by the 1930s that not even the Great Depression had any effect on him. For less fortunate artists, soup kitchens, often run by socialites, were established in Montmartre and Montparnasse.

o Chez André

This is the kind of traditional bistro once common near the Champs-Élysées before the advent of airline offices and duty-free shops.

12, rue Marbeuf
01.47.20.59.57
Wed-Mon noon-1am; Closed Tue
Métro: Franklin D. Roosevelt

p Le Boeuf sur le Toit

The original "Ox on the Roof" on the rue Boissy d'Anglas, near the place de la Concorde, was the hottest nightspot of the *années folles* ("the crazy years," the Roaring Twenties), one of the first in Paris to present *le jazz hot*. It was named for a Cocteau ballet and was the place where the elegant beau monde mixed with the bohemian *demi-monde*, the place, the poet claimed, where "everybody met everybody." Picasso attended the opening night in 1922 and was a regular along with Maurice Chevalier and Coco Chanel, whose couture house was a few blocks away on the rue Cambon. The cabaret moved to this location in 1941, although the Germans closed it for much of the Occupation.

34, rue du Colisée. 01.43.59.83.80
Daily noon-1:30am
Métro: Saint Philippe du Roule

q Chez Francis

Françoise Gilot recalled in her memoir, *Life with Picasso*, that the artist brought her here in the beginning of their relationship to lunch with his outgoing mistress, the photographer Dora Maar. Boasting one of the best views of the Eiffel Tower, the lively, expensive Chez Francis is convenient to the Musée de l'Art Moderne de la Ville de Paris.

7, place de l'Alma
01.47.20.86.83
Daily til 1am
Métro: Alma-Marceau

Les Champs-Élysées

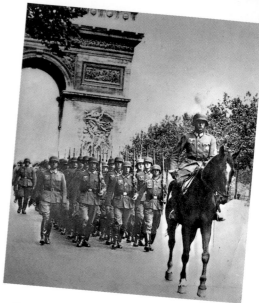

The world's best-known thoroughfare was laid out in the seventeenth century through marshlands as the main access from the palace at the Louvre to the one at Versailles. The lower portion of the two-mile avenue is still lined with gardens and was home to many fashionable amusement halls and theaters during the nineteenth century. Multiscreen cinemas now abound on the upper half of the street, which long retained the rural aspect suggested by its name, "The Elysian Fields"; only half a dozen detached *hôtels particuliers* had been erected among the trees when the long construction of the Arc de Triomphe began in 1808. During the Second Empire it became fashionable to build opulent mansions here. Most that remained after the explosion of commercial enterprise in the 1930s were requisitioned during the Occupation for high-ranking German officials. Today, the sole survivor, the Traveler's Club since 1903, stands at no.25.

Parisians have traditionally gathered by the thousands on the Champs-Élysées on momentous occasions, such as the mammoth victory parade in 1919 that celebrated the Armistice. After a mere two decades of peace, however, thousands of conquering Nazi troops entered Paris in June 1940 through the Arc de Triomphe, marching down the avenue in an intimidating show of strength. Four years later, Allied forces, swarmed by ecstatic locals, followed the same path as they liberated the occupied city.

Jardin de Paris

During his second trip to Paris and still under the influence of Toulouse-Lautrec, Steinlen, and Cheret, Picasso completed this poster for the chic summer branch of the Moulin Rouge, a popular outdoor music hall in the gardens of the Champs-Éysées. The exuberant cancan dancers, like the revelers in so many similar early works, would soon give way to the sick and downtrodden waifs of the Blue Period.

WALK 4
SAINT-GERMAIN-DES-PRÉS

WHEN MEDIEVAL PARIS OUTGREW the fortified Île de la Cité, it quickly spread to the two opposite banks of the Seine. The Right became the province of government and commerce, the Left that of the Church and academia. Saint-Germain-des-Prés, the area south of the island on the Rive Gauche, is the oldest part of the expanded town, named for the city's oldest church at the center of the quarter. Its quai des Grands-Augustins is the oldest of the city's embankments; it and the street of the same name that leads off it date to the fourteenth century. Many medieval houses still stand in the narrow, winding streets that distinguish the area from the grander parts of the city. In the years before World War II, when this historic district was still like "a village clustered around a church steeple," Picasso, by now the dominating force of Modern Art, came here to work and live.

As his marriage continued to fail, the artist who had always scorned bourgeois convention wearied of the pretentious, superficial world of the Right Bank and yearned to return to the non-conformist bohemian life that was more natural to him. He now chose this far more *sympathique* neighborhood – home to art schools, small galleries, antiquarians, booksellers, bookbinders, and the *bouquinistes* along the Seine. Here he would rediscover the intellectual Paris of his youth now gathered in the smoke-filled cafés near the church on the boulevard Saint-Germain.

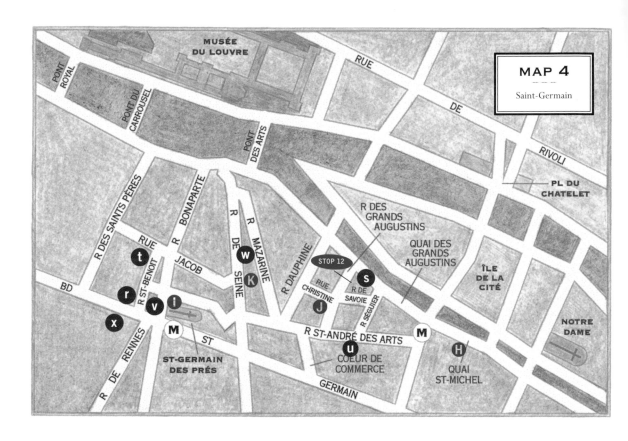

LEGEND

STOP 12 Studio, then residence of Picasso (from 1937) — 7, rue des Grands-Augustins

H Residence of Henri Matisse — 19, quai Saint-Michel

I Monument to Guillaume Apollinaire — churchyard of Saint-Germain-des-Prés

J Residence of Gertrude Stein and Alice Toklas — 5, rue Christine

K Residence of Picasso (1902) — 57, rue de Seine

r Café de Flore — 172, boulevard Saint-Germain

S Lapérouse — 51, quai des Grands-Augustins

t Le Petit Saint-Benoit — 4, rue Saint-Benoit

U Chez Allard — 41, rue-Saint-André-des-Arts

V Café des Deux Magots — 170, boulevard Saint-Germain

W La Palette — 43, rue de Seine

X Lipp — 152, boulevard Saint-Germain

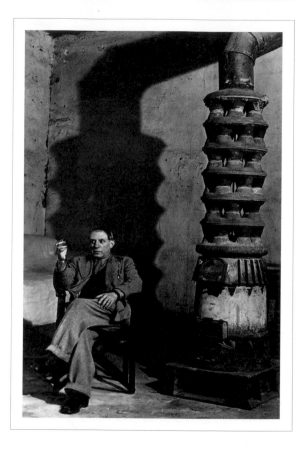

Brassaï: Picasso in his Studio,
rue des Grands-Augustins, *1939*

7, rue des Grands-Augustins, studio and then residence of Picasso from 1937

Métro: Saint-Michel

N EARLY FORTY YEARS AFTER the Universal Exposition that first brought Picasso to the French capital, a commission to provide a large-scale mural for the Spanish Pavilion of the 1937 Paris World's Fair necessitated a long-desired move as the rue La Boëtie studio was too small. The artist's new companion, the painter and photographer Dora Maar, went in search of a new place in Saint-Germain-des-Prés. It was at the neighborhood's Café des Deux-Magots (v) in 1935 – the year that Marie-Thérèse gave birth to Picasso's daughter Maya – that he had met this woman who would become his principal companion and model for the next decade.

The studio she found at 7, rue des Grands-Augustins, just off the quay, intrigued Picasso, who marveled at the eccentric grandeur of the seventeenth-century *hôtel particulier*, a far more aristocratic building that possessed something of the romantic mystery of his beloved Bateau-Lavoir. The greatest attraction, however, was that this had been the setting of Honoré de Balzac's *The Unknown Masterpiece*, a novella about the quest for artistic perfection that had obsessed Picasso. He had already

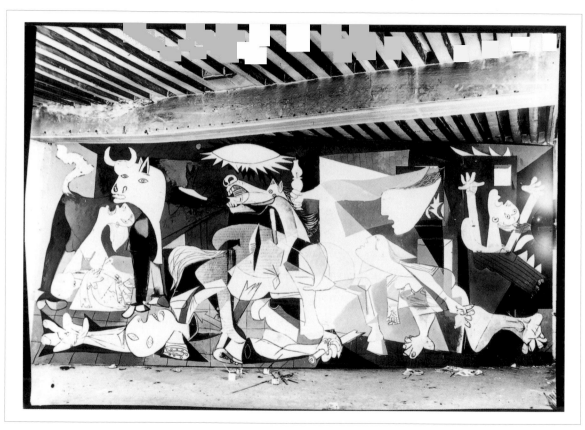

Dora Maar: Guernica, *(state vii), 1937. Archives Picasso, Musée Picasso, Paris*

made several etchings devoted to the story of an aging painter who had struggled for years on a single portrait until it became an unintelligible mass of corrections that he alone could decipher. For Picasso the house here was "full of literary and historical ghosts."

PICASSO AGAIN TOOK THE top floor and attic reached by the steep winding staircase in the corner of the walled cobblestone courtyard that faces the street. He marked the doorbell of his new domain with a hand-written scrap of cardboard that simply proclaimed "*ICI*." The labyrinth of cavernous rooms and small nooks was transformed into different studios for painting, sculpting, and engraving. There were hidden stairways, dark corridors, and rough-hewn oak beams supporting the rafters. Now amid his famous studio clutter were added stacks of books, catalogues, and magazines about himself, as well as a number of guitars and mandolins he had bought as a reminder of his own Cubist stilllifes. Wicker cages filled with turtledoves and more exotic birds greeted the many visitors who entered the large main reception room, among them Jean-Paul Sartre, Simone de Beauvoir, Albert Camus, André Malraux, and Cocteau, who described his old friend in this dusty bohemian splendor as "a tramp under a bridge of gold." For the first few years, Picasso only worked here, continuing to reside on the rue La Boëtie. Dora Maar, who never lived with the artist but was available at a moment's notice, took an apartment right around the corner from the studio at 6, rue de Savoie.

Procrastinating for months on the mural, Picasso suddenly found his subject on April 26, 1937,

when German bombers flying for Franco attacked a small Basque market town of no strategic value, killing and wounding thousands of civilians. *Guernica* quickly began to take shape, its mournful color scheme inspired by the black-and-white news photos of the destruction in the Paris daily papers, its terrified, distorted silent figures giving voice to the dread with which the larger looming conflict was anticipated. Ironically, it was here in the house of *The Unknown Masterpiece* that Picasso created what is arguably the best-known masterpiece of the entire twentieth century.

As Germany invaded one country after another, most Parisians who could afford to fled the capital. In cars, on bicycles, some on foot, trundling their belongings in handcarts, they jammed the streets around rail stations and the roads leading south out of the city. Picasso, too, attempted to pack up the hundreds of paintings, sculptures, drawings, engravings, and studies in the hopes of removing them from a Paris most feared would be destroyed. Though the only canvases he kept at his two addresses were unsigned and therefore less attractive to potential thieves (paintings with signatures, including many earlier works he had bought back, were locked away in an underground bank vault on the boulevard des Italiens), he soon gave up on the overwhelming task. After some hesitation, he determined that he and his works would just wait out the crisis in Paris.

WITH THE WAR, OF course, came the Occupation, with its rations, shortages, and transportation problems. There was no coal to heat either of his enormous establishments (during the war winters

he worked bundled against the cold as he had so long ago in his Montmartre garrets), nor was there fuel for his car. Air-raid warnings meant that a simple trip on the métro could last all day; buses were few and far between. By 1942 the sixty-year-old Picasso found it increasingly difficult to travel between his Right Bank residence and Left Bank workplace. He moved into the rue des Grands-Augustins, keeping the two grand apartments in one of the best parts of town simply for storage. The city was nearly deserted, most shops closed and shuttered, the boulevard Saint-Germain like a quiet provincial lane, with a ghastly blue light as the only illumination during blackouts. Clocks were reset to German time, streets that had been named for Jews rechristened, the Eiffel Tower forbidden to all but occupation forces. The nearby Palais du Luxembourg had become the headquarters of the Luftwaffe. As seventy-five percent of French produce, livestock, and wine was diverted to Germany, many Parisians raised rabbits and hens in their apartments. Chronicling the artist's wartime life, the photographer Brassaï recalled the grim changes to their city in his book *Picasso and Company*:

> "…The Paris we loved became a Paris of green uniforms and swastikas floating above the public buildings and the great hotels, headquarters for the Kommandantur and the Gestapo; a Paris without taxis, without cigarettes, without sugar, without chocolate; a Paris of rhubarb and turnips and saccharine; a Paris of queues and ration tickets, of curfews and jammed radios, of propaganda newspapers and films; a Paris of German patrols, of yellow stars, of alerts and searches, of arrests and bulletins of executions."

Though occasionally harassed by the authorities, Picasso's international fame did much to protect him and he was largely left alone during the Occupation. With few of his old friends in the city, he went less often to the cafés but consoled himself at his favorite black-market restaurant, down the street at 16, rue des Grands-Augustins, next door to a studio annex he had taken despite the vast space he already had at his disposal. It was while dining at Le Catalan, named for its illustrious neighbor, in 1943 that Picasso met Françoise Gilot, the young art student who would later become his mistress and bear him another two children.

In the summer of 1944 as the Allies moved toward Paris street fighting between the Resistance and occupying forces intensified, with explosions rattling Picasso's windows and passing tanks shaking the old floorboards of his studio, which was so close to the Préfecture of Police on the Île de la Cité at the center of the battle. He left to join Marie-Thérèse and Maya in their apartment overlooking the Seine at 1, boulevard Henri IV, on the Île Saint-Louis. When he returned to the rue des Grands-Augustins in the first heady days of the Liberation he was overwhelmed by a flood of visitors. First came American GIs, who ranked Picasso along with the Eiffel Tower as one of the "sights" they most wanted to see in Paris. With the artist's consent the Red Cross organized tours of the studio for them. Reporters and photographers, museum curators and artists, friends who had spent the war elsewhere soon followed. Picasso pronounced, "It's an invasion! Paris was liberated, but I am continually under siege."

By the late Forties Picasso increasingly preferred to stay in the South of France in a succession of villas and mansions, one of which he reportedly bought with a drawing. He and Jacqueline Roque, who would become his second wife in 1961, did, however, live on the rue des Grands-Augustins for a time in the mid-1950s.

End of Walk 4

Ⓗ 19, quai Saint-Michel, residence of Henri Matisse

Matisse lived here off and on for many years, first between 1895 and 1908 in a sky-lit garret with no view of the street. Returning to this address in 1913, he took a tidy three-room apartment one floor down that looked out over the river, the bridges, and Notre-Dame Cathedral, all of which he repeatedly painted from his window. During each stay he remained largely aloof from the artist communities of Montmartre and Montparnasse. This other great vanguard artist of the twentieth century is often compared to Picasso, twelve years his junior, a friend but also a rival for the entire half-century of their acquaintance. They were as different as Parisians as they were in temperament and in their art – "North Pole, South Pole" was Matisse's comment when the two met in 1906. Unlike the prodigy, who contrived to stay in Paris against all odds, Matisse was past twenty when he stumbled upon

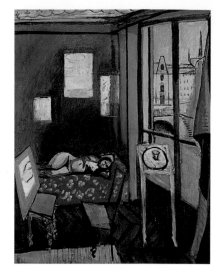

Henri Matisse: Studio, Quai St. Michel, *1916.*
The Phillips Collection, Washington, D.C.

painting as a career and had neglected even to visit the Louvre on his first trip to the city as a law student. While Picasso went through dozens of mistresses and embodied *la vie de bohème,* Matisse settled into a traditional bourgeois marriage. Even in their needs to get away from Paris they were completely different: the Spaniard could not tolerate the city's summer heat; the Frenchman hated its long grey winters.

Paris at War

As war threatened, anxious Parisians first evacuated the city's children, sandbagged Notre-Dame, and removed 200 truckloads of art from the Louvre to the relative safety of chateaux throughout the countryside. Cafés put up dark curtains in order to stay open through blackouts; the monkey house in the bois de Vincennes became an air-raid shelter. More than half of the five million inhabitants fled, though many returned following the surrender of Paris in June 1940, when German occupation reduced the likelihood that the capital would be destroyed.

Of the thousands of art works the Nazis confiscated, many were deemed stylistically unfit or unsellable. In May 1943, these were convoyed to the courtyard of the Jeu de Paume, where a bonfire reduced to ashes more than 500 canvases by Ernst, Klee, Léger, Miro, Picabia, Picasso, and others. Portraits of Jews were temporarily stored at the Louvre before being slashed to pieces.

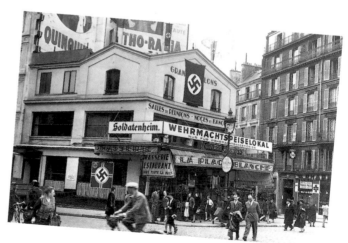

Shortly before the Liberation in August 1944, some of the heaviest street fighting between the Germans and students from the Sorbonne broke out in the place Saint-Michel beside the fountain of the saint slaying the dragon. The boulevard was quickly barricaded by the emboldened French Resistance. On August 25th the tricolor was raised atop the Eiffel Tower for the first time since 1940.

❶ Monument to Guillaume Apollinaire

After decades of wrangling between Picasso and the Apollinaire memorial committee over how to honor the charismatic poet, the artist finally offered a work that had been lying around his studio. This bronze of Dora Maar, a woman who had come into Picasso's life nearly

twenty years after his friend's death in 1918, was finally placed in the churchyard beside St.-Germain in 1959, facing the street that had been renamed in his honor. Apollinaire's last resi-dence at 202, boule-vard St.-Germain is a few blocks away. He is buried at Père-Lachaise.

❿ 5, rue Christine

Gertrude Stein and Alice Toklas, now in their sixties, moved to this building in 1938, and became even closer neighbors of Picasso's than they had been twenty-five years earlier in Montparnasse. That same year, Stein published her most successful book of the period, a recollection of her decades-long friendship with the artist. The women spent most of the war at their country home in eastern France – where the entire village kept silent about the two American Jews – returning to Paris just once in the middle of the night to quietly retrieve the Picasso portrait. After the Liberation, American soldiers in Paris also came to the rue Christine to meet the now-famous writer. Following Stein's death in 1946, Toklas lived on here for another two decades, until she was evict-ed shortly before her death in 1967. The women are buried side by side at Père-Lachaise.

ⓡ Café de Flore

The Flore was already seventy years old when the Montparnasse artists and writers moved to the red-leather banquettes here during the Occupation because their customary cafés became overrun with Germans. During the Thirties, this had become a gathering spot of young writers, academics, and political refugees. Jean-Paul Sartre recalled that he and Simone de Beauvoir "more or less set up house in the Flore," writing most of each day at one of the small marble tables at the top of the stairs to the second floor, until their growing fame forced them to less conspicuous places. Although Picasso also spent time at the rival Deux-Magots, this was his favorite café and his ultimate destination on most evenings. Accompanied by his friend

Brassaï: Picasso at the Café de Flore, *1939*

and secretary Jaime Sabartes and his ever-present dog Elft, Picasso would nurse a small bottle of Evian, chatting with his artist and poet friends who made the Flore their headquarters. Some days he would meet a string of people here by appointment, sign autographs, and watch those customers who weren't watching him.

172, boulevard Saint-Germain. 01.45.48.55.26. Daily 7am-1:30am
Métro: Saint-Germain

ⓢ Lapérouse

Like Picasso's studio, this restaurant, famous for its intimate private dining rooms and a favorite of General de Gaulle, is housed in one of the oldest structures in the area.

51, quai des Grands-Augustins. 01.43.26.68.04
Tue-Sat til 10:30pm (Closed Sun and Mon lunch)
Métro: Saint-Michel

ⓣ Le Petit Saint-Benoit

This inexpensive bistro, unchanged for much of its 140 years, was once a gathering spot for horse-drawn-cab drivers. Later, Sartre and de Beauvoir, regulars at the Café de Flore just up the street, often dined here at the long communal tables.

4, rue Saint-Benoit. 01.42.60.27.92
Mon-Fri noon-2:30pm, 7-10pm
Métro: Saint-Germain

ⓤ Chez Allard

During the 1930s the rue Saint-André-des-Arts was a street of inexpensive tailors when this Burgundian bistro opened several years before Picasso moved to his nearby studio. The zinc-topped bar, however, dates back to an even earlier establishment that was in business here during the artist's first stay in the neighborhood at the beginning of the century.

41, rue Saint-André-des-Arts
01.43.26.48.23
Open til 10pm (Closed Sun and Aug)
Métro: Odéon or Saint-Michel

ⓥ Les Deux Magots

Founded in 1875, the café across from the Romanesque
church had become by the 1930s the meeting place of
André Breton and the Surrealists, who had their own
table facing the front door. It was here at the Deux-
Magots on the night she met Picasso that Dora Maar
engaged in one of the more eccentric actions she was
famous for: a dangerous game of chance, in which she
rapidly stabbed at the wooden café table beneath her splayed fingers
with a knife until she had repeatedly bloodied herself.

170, boulevard Saint-Germain. 01.45.48.55.25. Daily 8am-2am
Métro: Saint-Germain

ⓦ La Palette

A favorite of Guillaume Apollinaire, who lived nearby on the boule-
vard Saint-Germain before his death in 1918, this artists' café was
already open in 1902 when Picasso stayed at a hotel a few doors
down the street at no.57.

43, rue de Seine
01.43.26.68. 8am-2am (Closed Sun and Aug)
Métro: Saint-Germain or Mabillon

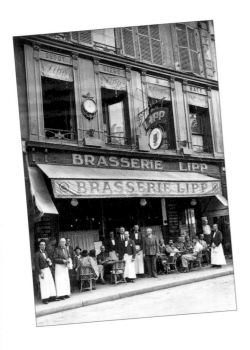

Lipp

Among the established, successful clientele of politicians, lawyers, actors, and writers, Picasso often dined at this Alsatian brasserie with other artists, including Alberto Giacometti, who would arrive with his hair and clothing covered with clay dust. It was said that here at Lipp, "for the price of a draft beer, one can have a faithful and complete summing-up of the political or intellectual day in France."

152, boulevard Saint-Germain. 01.45.48.53.91. Daily 8am-2am
Métro: Saint-Germain

Among the scores of American soldiers who came to pay their respects to Picasso at the war's end was Ernest Hemingway, who left as a token a case of hand grenades inscribed to the artist.

Although Picasso was respected and sought out by some of the more cultured occupying Germans, he had been branded a "degenerate artist" and an enemy of Franco by the Nazis, who forbid the exhibition of his work and kept close watch over the rue des Grands-Augustins studio. The painter often repeated an anecdote about the visiting officer who, examining a photo of Guernica, had asked: "So it was you who did this?" "No," Picasso claimed he responded, "you did."

THE 1937 EXPOSITION

The mammoth competing structures erected by the Soviets and the Nazis on either side of the pont d'Iéna dwarfed the other national pavilions on the fairgrounds on the Champ-de-Mars. The severe Thirties neoclassicism of much of the architecture can be seen today in two of the few remaining buildings constructed for the exposition, the Palais de Chaillot on the Trocadéro and the Musée d'Art Moderne in the Palais de Tokyo, a few blocks east along the Seine.

Place du Châtelet

At the Théâtre du Châtelet, on the Right Bank opposite the quai des Grands-Augustins and the Île de la Cité, the opening performance of *Parade* at the height of World War I was greeted with hissing, catcalls and shouted accusations of German complicity in the offensively avant-garde production. Across the *place* twenty-three years later, the Nazi occupation forces chiseled off the name of the Jewish actress from the Théâtre Sarah Bernhardt (today Théâtre de la ville de Paris).

The medieval sculpture in the Musée Cluny on the boulevard Saint-Germain at the boulevard Saint-Michel fascinated Picasso. He had briefly stayed near the museum in the Hôtel des Écoles on the rue Champollion until his money ran out on his unhappy third trip to Paris in 1902.

Les Bouquinistes

Booksellers had plied their trade on the congested early bridges and along the banks of the Seine beside fishmongers and other vendors since the sixteenth century. For the past hundred years permits have allowed the sale of books, maps, prints, and postcards from permanent padlocked wooden boxes – always painted dark green – on the parapets of the quays overlooking the river.

🄚 57, rue de Seine

Picasso stayed in this building when it was the primitive Hôtel du Maroc on his third trip to Paris in the winter of 1902. It is ironic that today high-priced Picassos are featured in the windows of many of the small galleries that line the street where the artist claimed to have spent the most impoverished and degrading time of his life. Immersed in the Blue Period, he shared a tiny attic room here with a Catalan acquaintance, too ashamed by his current failures to face the friends across the city in Montmartre who had witnessed his earlier successes. Unable to afford canvas, paints, and other proper materials, he was mostly reduced to drawing on scraps of paper. The accommodations here – at five francs a week – were so miserable that Picasso often spent his days at the Louvre, just across the river from the end of the street, where he could work more comfortably in the far warmer and better lit galleries.

Balthus

Picasso knew Balthus and owned some of his work. In fact, it was his purchase of one of the artist's seemingly conservative figurative paintings that assured Balthus's acceptance by the Parisian avant-garde. Balthus was also a resident of the sixth arrondissement, living a short distance from the rue des Grands-Augustins in the Cour de Rohan, a courtyard just off the narrow medieval alley, the passage du Commerce Saint-André, pictured in this work. Here he captures the simple daily activity, the unpretentious character, that distinguishes a typical Saint-Germain street from the grander, more bourgeois parts of the city the artist disdained. Balthus became a lover of Dora Maar after her relationship with Picasso had ended.

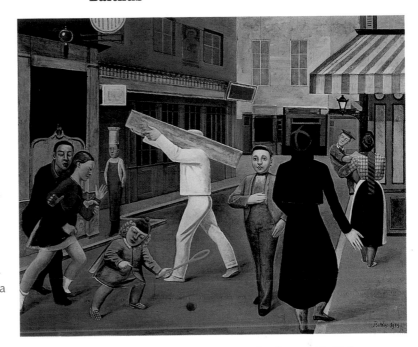

Balthus: The Street, *1933. The Museum of Modern Art, New York*

AFTERWORD

B Y THE LATE FORTIES Picasso spent more and more of his time in the South of France, return-
ing less and less frequently to Paris. Legal proceedings begun during the postwar housing
shortage led to his eviction from the two large apartments on the rue La Boëtie in 1951, more than
a decade after he had essentially abandoned them. Then in the late Sixties the studio on the rue des
Grands-Augustins was also wrested away from the elderly artist in another lengthy, demoralizing
court battle. By then most of his original Parisian friends and associates had died: Matisse in 1954;
Léger the following year; both Braque and Cocteau in 1963.

A stay at the American Hospital in late 1965 for a gallbladder operation would be Picasso's last
time in the city. To avoid the hordes now interested in his every movement, he registered as Monsieur
Ruiz, seeking anonymity once again in the forgotten name he had first brought to the French capital
six and a half decades earlier. In 1970, two of his most beloved places in Paris – the Bateau-Lavoir
and the Cirque Médrano – were destroyed. In 1973, the fifty-six-story Tour Montparnasse overtook
the Eiffel Tower as the tallest structure in the city, rising over the newly "revitalized" neighborhood
that Picasso had known for its spacious ateliers, artists' cafés, and open fields. In April of that same
year the ninety-three-year-old artist died at his home in Mougins.

MUSEUMS

Musée National de l'Art Moderne, Centre Georges Pompidou

rue de Renard. 01.44.78.12.33
Mon, Wed-Fri noon-10pm; Sat, Sun 10am-10pm
Closed Tue
Métro: Rambuteau

Opened shortly before Picasso's death, the museum of twentieth-century art on the fourth floor of Beaubourg represents the third national collection – chronologically following those at the Louvre and the Musée d'Orsay – in the capital. Not surprisingly, the work of the French and foreign artists, including Fauvists, Cubists, Futurists, Dadaists, and Surrealists, who lived in Paris during the first half of century are the strengths here.

Musée d'Art Moderne de la Ville de Paris

11, avenue du President Wilson. 01.47.23.61.27
Tue-Fri 10am-5pm; Sat and Sun 10am-7pm
Closed Mon
Métro: Iéna or Alma-Marceau

Built in 1937 for the Universal Exposition, the austere neoclassical building now houses the city's small but choice collection of modern art. Picasso's *The Burial of Casagemas*, one of the most important works here, had been used by the artist as a screen to hide the worst of the clutter in the studio at 13oter, boulevard de Clichy where it was painted a few months after the poet's death.

Musée de l'Orangerie

place de la Concorde
01.42.97.48.16
Wed-Mon 9:45am-5pm
Closed Tue
Métro: Concorde

Located across the Seine from the Musée d'Orsay is the often overlooked collection of art dealer Paul Guillaume, whose portrait by Modigliani is just one of the 144 paintings dating from the 1870s to the 1930s on display. Works include canvases by Picasso, Matisse, Derain, Rousseau, Utrillo, Laurencin, and Van Dongen.

Musée Picasso

Hotel de Salé, 5, rue de Thorigny. 01.42.71.25.21
Wed-Mon 9:15am-6pm
Closed Tue
Métro: Chemin-Vert or Saint-Paul

The seventeenth-century mansion named for the hated salt-tax collector who originally lived here is now the apt home for the works that Picasso's heirs donated to the state in lieu of massive inheritance duties. In addition to the artist's own paintings and sculptures that he kept or repurchased is his personal art collection, including works by Rousseau, Matisse, de Chirico, Degas, Renoir, Corot, Cézanne, and others.

LIST OF ILLUSTRATIONS

All other photos by Angela Hederman

143

About the author

Ellen Williams, the author of *The Impressionists' Paris*, is the former art editor of *Vogue* and executive editor of *The Journal of Art*. She edited Alexander Liberman's *The Artist In his Studio* and *Keith Haring Journals*. She travels to France several times a year and has written about Paris for *Travel & Leisure*, *International Design Magazine*, *France Today*, and other publications. She lives in New York City with her husband and daughter.

Also from The Little Bookroom

The Impressionists' Paris
Walking Tours of the Artists' Studios, Homes, and the Sites They Painted
by Ellen Williams

This guidebook pairs some of the most beloved masterpieces with the exact locations where they were painted from the Pont Neuf depicted by Renoir to the Gare St-Lazare, the train station from which Monet departed for his home in Giverny. Carefully organized itineraries also include the artists' birthplaces, studios, and grave sites. An entertaining and informative text combining art history, Paris history, and anecdotes about the painters complements the full-color reproductions, 19th-century photographs, and maps. Dining recommendations at cafés and restaurants that date from the Impressionist era round out the tours. *The Impressionists' Paris* is an enormously engaging guidebook and an art book of lasting value.

"…this pocketable hardcover is a small marvel. It is fun to look at and fun to read."—John Russell *The New York Times*

"…an ingenious and admirably focused book…satisfying even to those who don't go to Paris."—*The Washington Post*

"…recreates the City of Light as seen through the eyes of such visionaries as Degas and Monet."—*Condé Nast Traveler*

ISBN 0-9641262-2-2 100 pages, hardcover, 5" x 7"